Creative DSLR Photography

Creative DSLR Photography

The ultimate creative workflow guide

Chris Coe and Chris Weston

AMSTERDAM · BOSTON · HEIDELBERG · LONDON · NEW YORK · OXFORD
PARIS · SAN DIEGO · SAN FRANCISCO · SINGAPORE · SYDNEY · TOKYO

Focal Press is an imprint of Elsevier

Focal Press is an imprint of Elsevier
Linacre House, Jordan Hill, Oxford OX2 8DP, UK
30 Corporate Drive, Suite 400, Burlington, MA 01803, USA

First published 2010

Notices

Knowledge and best practice in this field are constantly changing. As new research and experience broaden our understanding, changes in research methods, professional practices, or medical treatment may become necessary.

Practitioners and researchers must always rely on their own experience and knowledge in evaluating and using any information, methods, compounds, or experiments described herein. In using such information or methods they should be mindful of their own safety and the safety of others, including parties for whom they have a professional responsibility.

To the fullest extent of the law, neither the Publisher nor the authors, contributors, or editors, assume any liability for any injury and/or damage to persons or property as a matter of products liability, negligence or otherwise, or from any use or operation of any methods, products, instructions, or ideas contained in the material herein.

British Library Cataloguing in Publication Data
Weston, Christopher (Christopher Mark)
 Creative DSLR photography : the ultimate creative workflow
 guide.-(Digital workflow)
 1. Photography-Digital techniques-Amateurs' manuals
 2. Single-lens reflex cameras
 I. Title II. Coe, Chris
 775

Library of Congress Control Number: 2008943845

ISBN: 978-0-240-52101-5

For information on all Focal Press publications
visit our website at www.focalpress.com

Printed and bound in Canada

10 11 12 13 12 11 10 9 8 7 6 5 4 3 2 1

CONTENTS

CONTENTS

INTRODUCTION

Visualization and Creativity

What is photography? A simple question but one with many answers. Perhaps the simplest answer is – an individual interpretation of a visual world. The key words here are visual and individual. Very obviously, photography is all about light and without light photography simply doesn't exist. Light enables us to see, creating colors and shapes, tones and textures.

With seeing, the interpretation starts. We all see colors and tones slightly differently. Your purple may not be quite the same as my purple but, unless your vision is impaired by color blindness, we see colors distinctively enough to be able to distinguish one from another, then label and identify them.

Photography can be used to record an image of someone or something. It can create an exact representation in two dimensions. More pertinently and more excitingly, photography can be used more creatively to interpret the visual and alter it either subtly or dramatically. How we each choose to interpret is the individuality that makes photography so creative and fascinating.

Photography as a creative process begins in your head not in your camera. It is tempting to raise the camera to your eye and then start hunting for an image in the viewfinder but this misses out the most vital steps in the making of an image. Learning to see images is where creativity begins, then learning to visualize and interpret is where photography becomes most rewarding and your individuality starts to shine through.

Every photographer, when they first start photography, has trouble seeing an image and then capturing it. We've all returned from a photo shoot to be greeted with the disappointment of the photograph, on the computer screen or in the print, looking nothing like we saw it at the time we captured it. It's very frustrating and, at times, it feels like you're the only person who can't get the image you want. You aren't and you will progress beyond this point.

In this book we are going to focus on the creative side of photography and take you into a fascinating world where you will only be limited by your sense of adventure and creativity. To achieve this you must first see your camera as nothing more than a tool, a sophisticated tool maybe, but still just a tool. Like all tools the end product is determined by the skill of the person using them so it is essential to understand your camera, how it differs from your own eyes, and what it can and can't do.

Armed with this knowledge, you become free to explore the world of photography, to work with light, and to create highly individual images that other people will want to look at and enjoy.

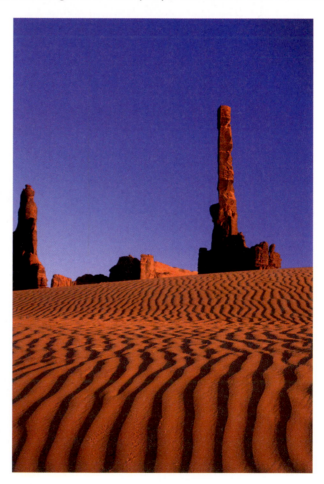

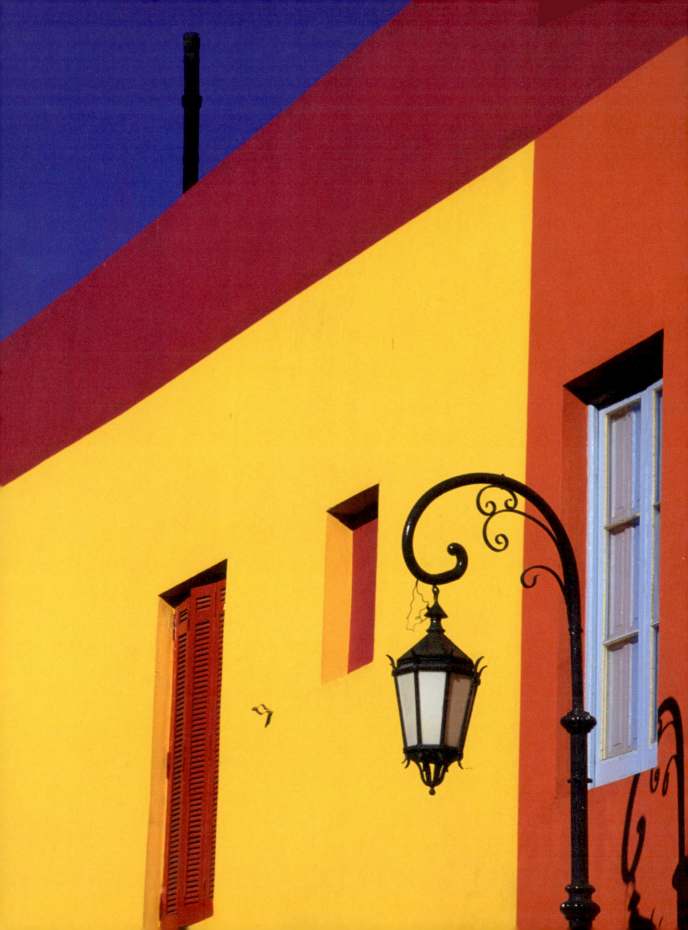

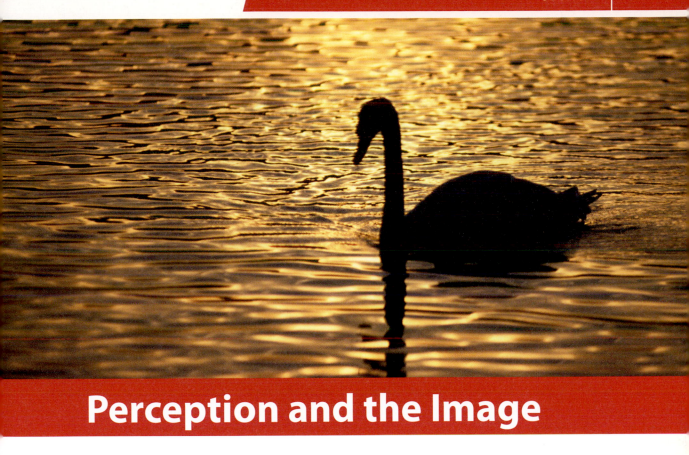

Perception and the Image

The Essentials of Light

Light is the photographer's paint. Any photograph starts as a blank canvas, so how you choose to apply light to it determines the visual attributes of a photograph. By manipulating light it is possible to reveal and hide objects, tones can be made lighter or darker, colors altered or replaced. Shadows can be softened, hardened or made to disappear, highlights lost or gained and shapes emphasized or flattened. Forget about the technological wizardry that is the modern day camera and think about light because, without it, the camera is about as useful as a car without an engine or, indeed, a canvas without paint.

We tend to think of light as being largely constant but this is far from true. If you are photographing in a studio then the studio lights can be set to give a constant output or intensity of light. Move outdoors and the intensity of natural light is determined and modified by a range of factors: time of day and the sun's elevation; where you are in relation to the equator; clear skies or cloud density; even the time of year.

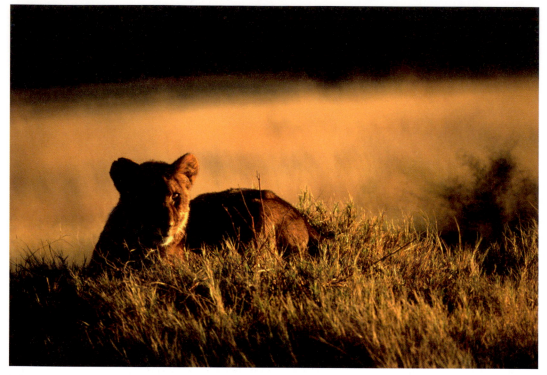

Light, and how the photographer uses it, can be the difference between an ordinary image and a strong one.

Understanding Natural Light

The intensity of light increases as the angle of the sun increases relative to the Earth. Put simply, the higher the sun is in the sky, the more intense the light. This is obvious if we think about what time of day the sun is hottest and brightest, and when it's easiest to get sunburnt – the middle of the day. On a sunny day, with no clouds to act as a diffuser, the light is more intense than on an overcast day when the clouds absorb and scatter the sunlight.

The equator is the point on the Earth which is closest to the sun so it follows logically that the light is most intense here. Move towards the poles and the sun's rays have further to travel to reach the Earth's surface, losing intensity on the way. The rotation of the Earth and its orbit create the seasons and variations in the number of hours of sunlight between summer and winter. Again, at the equator this remains largely constant and the length of the day varies very little, but move towards

The intensity of light changes depending on the time of day and the weather.

The intensity of light changes depending on the time of day and the weather.

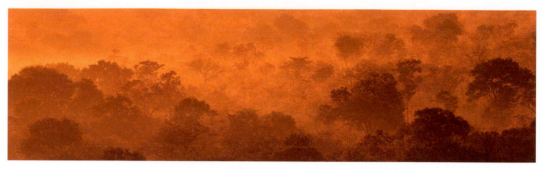

The intensity of light changes depending on the time of day and the weather.

either pole and the variations become much more marked. The further you move from the equator towards either of the poles, then the more marked the difference in the length of the days from summer to winter and with it the intensity of light between the seasons. Again, this is evident as the sun doesn't reach the same high point in the sky during winter as it does during the summer months.

The source of natural light, the sun, remains essentially constant but all these factors produce variations in light, altering its intensity and quality. Light can be hard or soft. Hard light is direct and undiffused from a single source; sunlight on a cloudless day. This creates strong illumination on the side of any subject facing the light source and strong shadows on the opposite side, giving distinct shadows with well-defined edges. Shine a spotlight onto an object placed in front of a wall and you'll see this.

Soft lighting illuminates less strongly and produces shadows with softer, less well-defined edges. Soft light is produced when a light source is diffused, or reflected by multiple sources, scattering it in different directions. Here, the side of the illuminated subject opposite to the light source is partially lit and retains some visible detail.

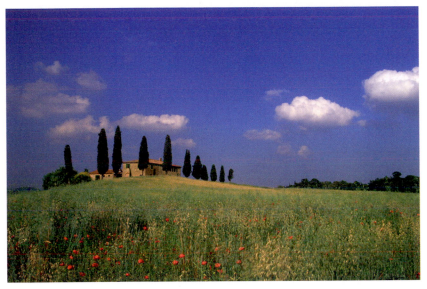

Strong light gives short shadows and high contrast between these shadows and image highlights. However it's still possible to create images which work by minimizing shadow areas and limiting contrasts.

This strongly lit image uses directional shadows to create definition and a sense of depth.

Light and Photography

This is all very interesting but what's it got to do with photography? Well quite simply everything! Cameras record the light falling on a subject, which is then reflected back and allowed to pass through the lens on a light sensitive recording device – film or digital sensor. The intensity and quality of light determines contrast and shadows. Both create a sense of depth, form and dimension that are essential in translating a three-dimensional subject in a two-dimensional photograph. Your ability to use light to do this will determine the impact your images produce, so this understanding of light is fundamental to successful image making, all the more so because cameras have a much more limited ability to record contrast than the human eye.

In hard light, shadows are strong and contrast high. At first you would think that this would make it easier to create a sense of depth but this is not necessarily the case, as the direction of the

Soft lighting reveals a myraid of subtle gradations in tone, giving the skin a soft texture and contours. This is especially important for flattering portraits.

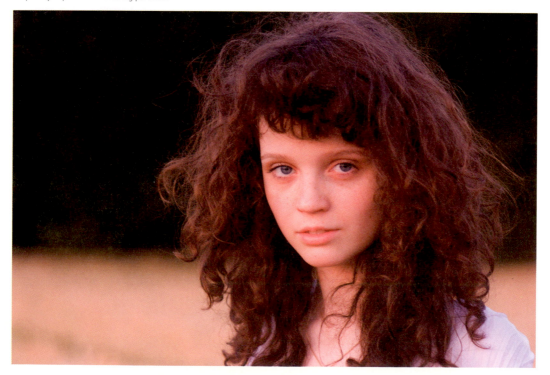

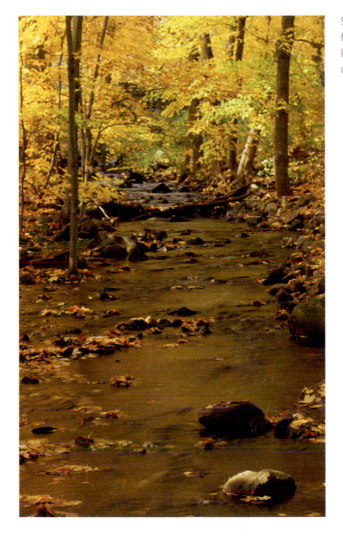

Soft light from an overcast sky, further diffused by the foliage, produce a subtlety of tone in this autumnal landscape. This shot was taken in the middle of the day when it was raining.

light is also important, and hard light tends to bleach out colors and tones, reducing subtle shading that creates contours. This is why the less intense directional light at the beginning and end of each day is favored by many photographers.

Soft light produces softer, less dense shadows and a lower contrast, revealing subtle shades of color and tone. However, if the light is too soft then a subject or scene can look flat and lifeless.

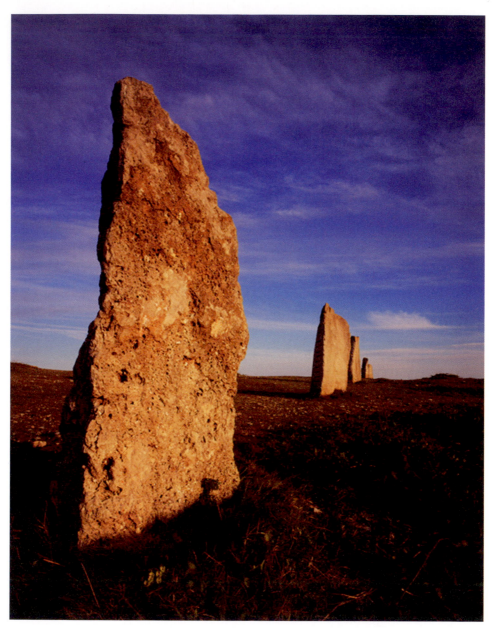

Direct lighting is described as hard and creates well defined shadows.

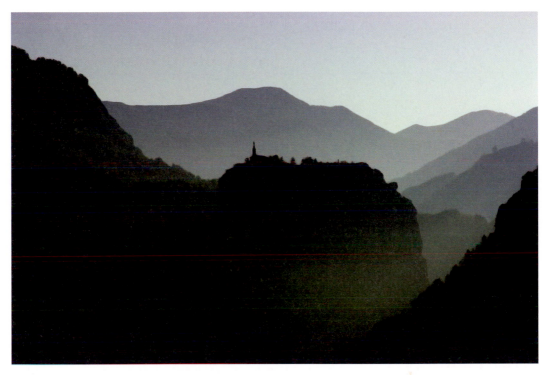

The direction of light affects how detail is revealed. Here, backlighting renders detail in silhouette.

The angle, or direction, from which light falls on a subject is an important factor in defining its appearance. Front lighting reveals detail but not texture, while side lighting emphasizes texture and form by creating shadows. Backlighting creates silhouettes or strong outlines with the golden halo effect of rim lighting.

With artificial lighting, the light source can be moved to alter the direction from which light falls onto the subject, as well as the intensity. With natural light, the photographer cannot move the sun so the only alternatives, if the light direction is not what you want, are to change your position or come back when weather or time of day produce a different light. The ability to read the light and understand how it's going to change is therefore fundamental to all photography, but particularly when using ambient natural light.

The warm, angled light just before sunset creates vibrant colors and accentuates the varied textures.

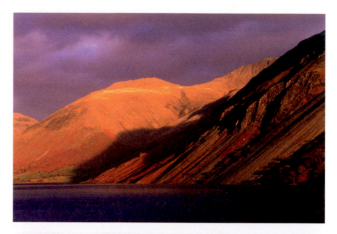

In the middle of the day the sun is directly overhead, shadows are short and contrasts high, reducing the subtlety of tone. This is particularly noticeable in the foliage of the trees where only a few shades of green are visible.

Low level early morning mist across the valley acts as a further diffuser, increasing with distance, for the already soft light. The mist-free foreground contrasts and compliments the lone tree.

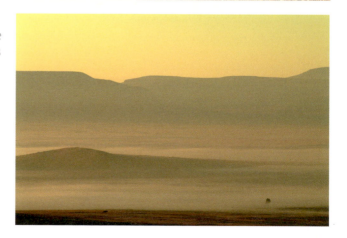

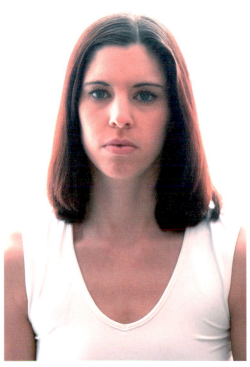

Shot in diffuse light this picture of a woman looks like a snapshot.

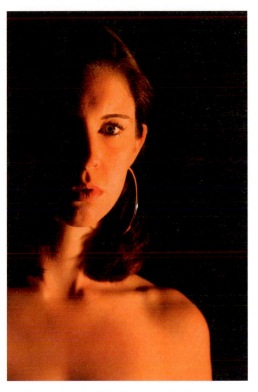

A single strong directional light picks out one side of the same woman's face. The other side, in shadow, creates strong contours giving striking impact to the face and, in particular, the model's eye. The light has transformed her and it takes a second look to be sure that this is the same woman.

Light and the Camera

The camera sees the world very differently to the way in which we see it. It is only by understanding these differences that you can use them to be creative with your photography.

Two fundamental differences come immediately to mind. First, we have two eyes, but the camera has only one. Having two eyes enables us to calculate the distance between objects. Try looking at two objects that are different distances away from you, then close one eye. You'll immediately notice how the sense of depth, created by two eyes, is no longer apparent and that the scene in front of you changes from three-dimensional to

two-dimensional – essentially flat. If you're not sure about this choose another two objects then look at them first with only one eye. Can you judge how far they are apart? Now open the other eye as well and you'll be able to determine this immediately. Two eyes therefore allow us to judge distance and are a key factor in creating perspective.

Cameras also effectively only see in black, white and shades of gray, whereas we see in color. Every color, and shade of color, has a corresponding shade of gray when viewed in black and white. At first this would seem not to cause a problem until you realize that red and green reproduce as very similar shades of gray! Try photographing a red and green pepper next to each other in black and white and you'll find it's impossible to tell which is which.

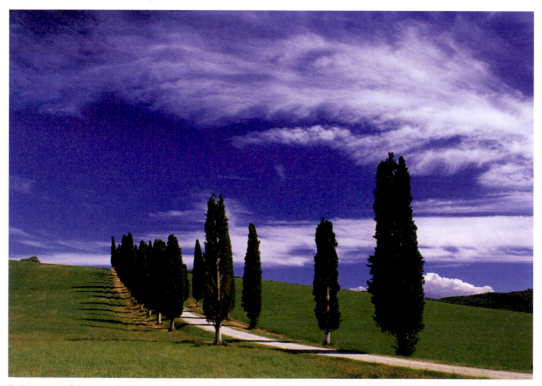

Having two eyes allows us to judge distance and perspective from the cues present in a scene. Here we interpet all the Cypress trees as being similar in size, with some appearing smaller because they are further away rather than simply being smaller trees.

Capturing the essence of a three-dimensional subject in a two-dimensional photograph is difficult enough, and these two differences between our eyes and our camera contribute towards this, but the fact that the camera is just an inanimate tool is never more clearly illustrated than when you think what else it lacks.

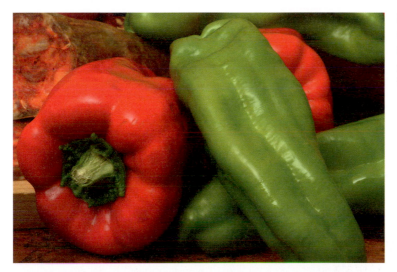

In color it's obvious which is the red and which is the green pepper. Shot in black and white, these two colors reproduce as similar tones and it's impossible to tell the difference.

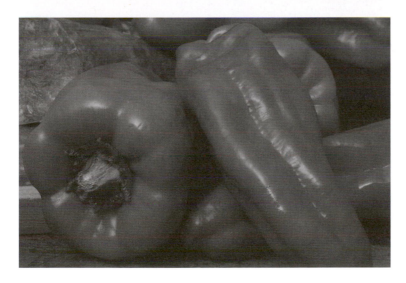

Stimulate the Senses

What makes us want to photograph something? It's a combination of the visual stimulation of seeing something which appeals and all our other senses working together at the time to create a response to the subject; sound, smell, feel and even taste. Sight is obviously the dominant one but all the others help to form our awareness and appreciation of what we see. Take an interesting landscape, for example. The sounds that fill the air, from the movement around us to the breeze through foliage and on our skin, the aromas that fill our nostrils, the textures that stimulate our sense of touch and the sweet or bitter tastes in the air around us are all assimilated by our brains to supplement the visual stimuli and create the atmosphere which we want to capture in our images. When you press the shutter, however, the camera only records what it sees, using one eye in black and white, and four out of the five senses that influence how you respond emotionally to the subject are lost.

Photographs often fail because they capture only the visual without stimulating the other senses of smell, sound, touch and taste. Capturing, or at least hinting at, these other stimuli can add another dimension to an image.

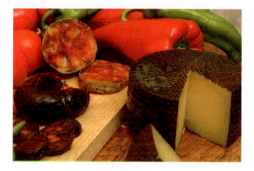

Can you almost taste or smell the food? If so then the photographer has succeeded in adding an extra element to the image.

When you think about it, it's little wonder that a two-dimensional, single-sense photograph might struggle to live up to the actual experience we had at the time we were making it, and when we view our own photos, sound, smell, touch and taste are all still attached in our minds to the image we see in front of us. For someone else viewing your images these four senses are missing, leaving only the visual. The real skill in photography, and what sets the great images apart from the snapshots, is the ability to replace this missing/lost information using purely visual tools, to give the viewer a sense of what you felt when you were making an image by recording it in such a way that it stimulates the imagination and stirs emotions.

It is a skill that can be learned and the starting point is to get into the habit of seeing what your camera sees.

Understanding Color

We tend to view color as absolute – a leaf is green, when in reality it is determined both by the physical properties of an object and the light falling on it. Color is in fact a perception. Color is first determined by the absorptive and reflective properties of the object; a red door absorbs all the wavelengths of light except red, which it reflects, so we see the door as red. What shade and intensity of red is then determined by the light falling on and being reflected from it.

We tend to think of natural light as being white but in fact all light is made up of the primary colors – red, green and blue which combine to make white – and has a color temperature. Sunlight is not a constant color temperature throughout the day and the changes are most marked, and most noticeable, toward the extremes – sunrise and sunset.

Color is determined by a combination of the physical properties of an object and the light falling on it.

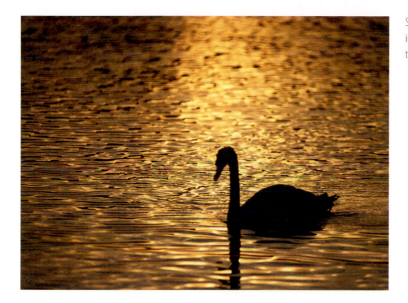

Soft light on rippled water creates texture in this image, contrasting strongly with the hard silhouette.

Think about what happens to a piece of metal when it's heated in a furnace. As well as getting hotter it changes color. First it goes red, then orange, yellow and finally, at its hottest point, a blue/white color. A similar thing happens to the color of light as the sun rises throughout the day, then in reverse towards sunset as the sun moves lower in the sky and the light becomes less intense again. The color of the daylight is determined by the wavelengths of light which are absorbed by or allowed to pass through the Earth's atmosphere.

In the absence of direct sun before sunrise and after sunset, the light has a bluish tinge. At sunrise the color temperature of the direct sunlight is low, resulting in its reddish appearance. In the early morning light color changes rapidly, becoming orange, then yellow, then finally white leading up to noon. In the afternoon, the changes are reversed in the same way that the changes in the color of metal are reversed as it cools from its hottest point.

It is the color temperature of light that makes sunrise and sunset, early morning and late afternoon, or early evening, the ideal times for natural light photography, times of the day we refer to in photographic circles as the 'golden hours', as the warmth of the color of light around these hours shines through. Combine

Stark contrasts in color create strong shapes which define this image.

this with a low angle of illumination by the sun, less intense light and softer shadows and tones, and creating both depth and atmosphere in an image is greatly enhanced.

Digital cameras are calibrated for natural light at its most constant in the middle hours of the day. If you take photographs nearer sunrise and sunset then the color temperature shifts will record as color hues in your images and the colors which we see at these times will be evident. However, digital cameras can be recalibrated using the white balance facility. If you do this, when photographing in say an early morning orangey light, then the orange will be removed and the light look much more like that at midday in color, but with the intensity and direction of early morning low light.

Color determines so much in our world and in our photography. It is ironic, then, that the camera doesn't see it as anything other than tones, or shades of gray, even when recording an image

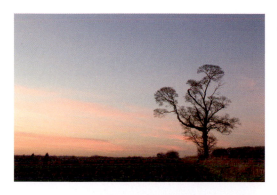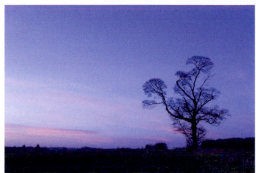

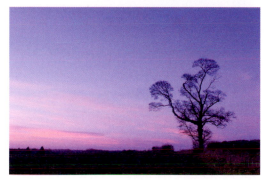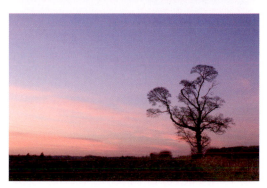

The color balance settings on a digital SLR are used to correct color casts but they can also be used creatively to enhance color. The first shot (top left) shows a sunset sky photographed using the auto white balance settings. Choosing the tungsten light setting (top right) adds a blue tone while the fluorescent light (bottom left) setting adds a magenta tone. The sunlight setting (bottom right) adds a subtler warm cast.

in color. It's therefore important to understand how the camera sees a color subject, assesses it in black, white and shades of gray, then translates it back into color in the recorded image. Through this understanding we can then start to play with color as a creative tool.

Tone and Contrast

If you look at a plain blue sky your brain says, 'That's a plain blue sky'. Point your camera at the same sky, however, and the camera sees nothing but monotone gray. Add some clouds and your brain will inform you that you are seeing a cloudy blue sky. Once again, however, all your camera will see are gray tones. A pattern is emerging here – all that a camera ever sees is tones of gray or, in other words, contrast.

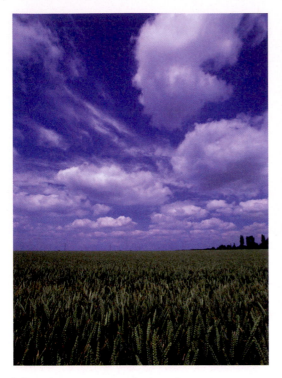
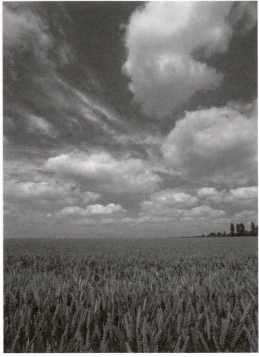

Unlike us, the camera sees tone and contrast rather than color. These contrasting tones are used not only to calculate exposure values but also by the camera's auto-focus system. To understand what the camera sees you must learn to visualize colors as tones.

Contrast is important in several areas of photography. For example, camera auto-focus systems use contrast to determine focus, it affects light meter readings and exposure and, in terms of composition and visual information, contrast creates a sense of depth, adding a third dimension to an otherwise two-dimensional print or screen image.

If you use auto-focus, rather than manually focusing your lens, the importance of contrast will rapidly become evident when it is absent. Try auto-focusing your camera on a subject which is a solid color, or two similar shades of the same color, and the auto-focus will hunt around desperately trying to find a point of contrast to lock on to. Do this where two contrasting tones meet and focus is achieved rapidly.

With auto-focus, lack of contrast is nothing more than an inconvenience but when assessing exposure, composing an image or trying to create a sense of depth then it can easily ruin an image if you don't know how to work with it.

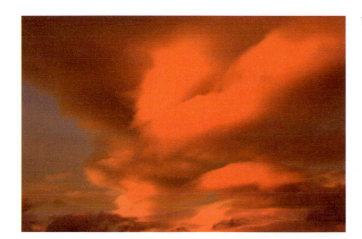

What tones does the camera see these colors as?

Understanding Exposure

Intensity of light determines exposure, but before explaining this it's important to understand what we mean by exposure. After selecting the ISO, or sensitivity, exposure is controlled by the aperture – the size of the hole that lets light through the lens – and shutter speed – the length of time that hole is open for. When we measure exposure the meter simply tells us the range of options for these two parameters which will give us the 'correct' or 'average gray' exposure. This exposure is often far from 'correct' of course because exposure depends also on the effect you wish to create.

In-camera meters work this 'correct' exposure out in a number of ways. Older cameras use an average metering system. This simply measures all the light coming through the lens which falls on the metering cell, then averages these tones all together to tell you what aperture and shutter speed will give you an average, mid-tone gray exposure. Slightly more sophisticated is center-weighted metering. Here the measuring process is the same but the reading is biased towards the values at the center of the frame, as the name suggests, and assumes that this is the most important part of your image.

Changing the metering mode can drastically alter the appearance of a scene. Here the top image was photographed with the camera set to multi-segment metering. For the bottom image, metering mode was changed to spot metering.

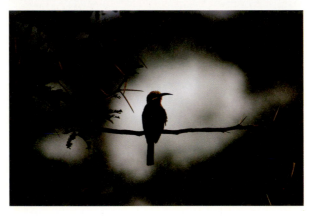

Most digital cameras have three metering options – multi-segment metering (sometimes called zonal metering), centre-weighted (or average) metering, and spot metering. Multi-segment metering takes measurements from points over the whole frame then tries to match them to a series of pre-programmed image scenarios. In doing so it tries to identify the most likely subject of your photograph, by matching tones and patterns of tones to pre-programmed options, calculating exposure accordingly. In centre-weighted metering mode, the camera skews the light reading towards the centre of the viewfinder. Spot metering is exactly as the name implies. A reading is taken from a spot in the frame, usually the center where the camera focuses, but this spot can be changed in some cameras. This metering option can be very useful but should be used with caution as it is easy for the meter to be tricked if you don't think about where you take the reading from.

Working with Light Meters

It's important to realize that all these ways of metering light are fallible despite their sophistication, so you need to be aware of how and when they can be tricked. The main reason that they're fallible, though, is because they measure reflected light. This is the light that is reflected back from the subject or scene, through the lens to the sensor. Now if you think back to when we were talking about color then you'll remember that the color of an object is determined by the light which it reflects. So, although they are in exactly the same light, different colors reflect different amounts of light. A bright yellow object will reflect back more light than a dull purple one and will give different meter readings, for example.

Hand-held light meters measure incident light – the light falling onto an object rather than the light reflected back by it. This is therefore independent of the color of that object, which is why hand-held incident meters tend to give a more accurate meter reading in most lighting conditions, especially in the most difficult ones. They are not tricked into seeing the color of the object which you are metering as mid-tone gray but simply record the light before any absorption or reflection caused by the color of the object.

What is often referred to as the 'correct exposure' is simply the exposure which your meter, measuring reflected light, tells you will give you average gray, and usually results in a photograph which simply documents the subject or scene as it appears to the eye. There is no creativity in this exposure process.

It is far more interesting to think of this 'correct exposure' as your starting point rather than the one which you actually use in making an image. Having understood what the camera thinks is the correct exposure, let's think about the process from the photographer's perspective and that of the image which we envisage in our head.

The greater the intensity of light, the faster the shutter speed or the smaller the aperture is needed to achieve our average gray exposure. So more intense light simply gives us greater flexibility in choosing exposure settings. For example, bright conditions will enable faster shutter speeds and smaller apertures, which

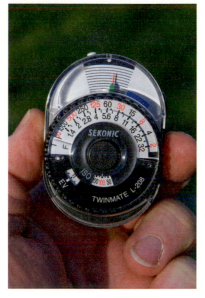

Light meters measure incident rather than reflected light. They are extremely useful especially in a difficult lighting condition when the DSLR's in-camera meter can easily give an inaccurate reading. By aligning the two needles aperture values, f-stops, and the corresponding shutter speed can be read off the dial.

may be required for freezing the appearance of motion or increasing depth of field, respectively. Of course, the opposite can be true. If a slow shutter speed is needed to blur motion or a narrow depth of field is desired to hide background detail, then lower intensity light can be advantageous.

Now what happens if we break the link between the metered aperture and shutter speed? Depending on which way we go, either reducing the amount of light entering the camera or increasing it, we darken or lighten the image. So why would we want to do this? Doesn't it just result in under- or overexposed images? Well only if you're still thinking in terms of exposure reproducing exactly what you see. Used creatively it can transform an image.

The Zone System Applied

In the 1940s, Ansel Adams and Fred Archer devised a method of controlling image exposure values that enabled photographers to expose a photograph for desired light and dark tones in a scene. That system is still in use today and is called the Zone System. In Adams's and Archer's day, the Zone System was synonymous with black and white photography, the various 'zones' being representative of the ability of black and white film to record detail across the tonal range. In other words, film latitude, or dynamic range, as we would now call it in digital terms. Despite its origins, with a little adaptation the Zone System can be applied to digital photography.

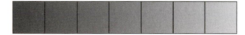

Metering for the Zone System

A camera's light meter sees the world and everything in it as 18% mid-tone gray, irrespective of whether it is or isn't – a swan's feathers, snow, a heap of coal, the night sky, everything according to the light meter is 18% mid-tone gray so the exposure value given by the meter, if applied by the photographer, will record the subject as medium tone.

For example, say you are photographing a snowy winter landscape. You set your camera to auto-exposure (AE) mode and take the photograph. When you review the image, you find that

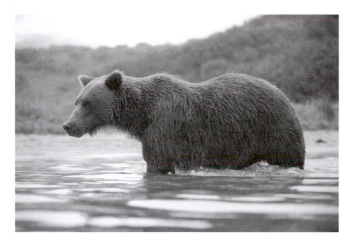

A dark brown bear is around 1-stop darker than medium tone (top image). However, when photographed at the camera's suggested meter reading, which is calculated for a medium-tone subject, the bear appears lighter (bottom image).

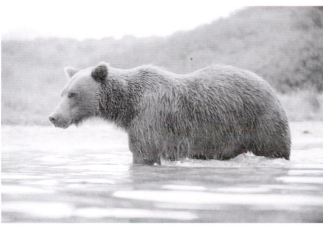

the snow looks gray rather than the same brilliant white that it is on the ground. The reason: the camera thinks it is gray, 18% mid-tone gray. The same thing occurs when photographing a dark subject. At the camera-assessed exposure value, a black bear, for example, would look more like a gray bear.

The 18% Gray Value

Light meters see colors as tones, or shades of gray. The value 18% refers to reflectance and relates to how humans perceive medium gray (mid-tone gray). With absolute black as the darkest shade of gray at one end of the range and absolute white as the

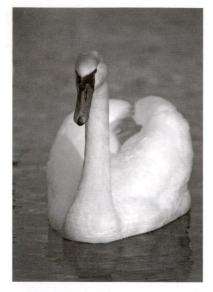

A photograph of a white subject will be under-exposed if shot at the camera's suggested meter reading (bottom image). For a faithful reproduction of the white tones, exposure compensation must be applied, in this case +2-stops (top image).

lightest at the other, the average digital camera sees 7 stops of dynamic range. Medium gray lies in the middle. The human eye is much more sensitive and sees 14 stops of dynamic range but this is currently beyond any camera's capabilities.

The diagram on page 26 shows scene tonality broken down into seven segments from textured black to textured white and numbered from 2 to 8 (representing the original zonal values given by Adams and Archer). The middle segment (zone 5) represents mid-tone (18%) gray. To the right of the middle box is light gray (zone 6) and very light gray (zone 7), being 0.5 stop and 1 stop brighter than medium tone, respectively. On the far right is textured white (zone 8), which is 1.5 stops lighter than medium tone.

To the left of the middle box is dark gray (zone 4) and very dark gray (zone 3), being 0.5 stops and 1 stop darker than medium tone, respectively. On the far left is textured black (zone 2), which is 1.5 stops darker than medium tone.

By deciding in which of the seven boxes the tone of the metered subject falls, it is easy to see by how much the camera is under- or overexposing the subject in order to render it mid-tone gray. For example, white snow would fall into the box marked zone 8 (textured white), far right, which is 1.5 stops brighter than medium tone. To make white medium tone, then, the camera will underexpose by 1.5 stops. Therefore, if the desire of the photographer is for white snow to appear white in the photograph, in order to compensate for what the camera is doing, the photographer must apply an equal and opposite amount of exposure compensation, which, in this example, is +1.5 stops. In other words, overexposing by 1.5 stops.

At the opposite end of the scale, if the subject of the photograph were textured black in tone, this would fall into the box far left, marked zone 2 and equal to 1.5 stops darker than medium tone. In order to record a subject that is textured black as a medium tone, the camera will overexpose by 1.5 stops. Again, in order to reproduce the correct tone (i.e. textured black) in the photograph, the photographer will need to apply an equal and opposite amount of exposure compensation – in this example, −1.5 stops, or 1.5 stops of underexposure.

In camera metering systems measure reflected light i.e. the light which hits a subject and is reflected back to the camera. The color of an object is determined by the wavelengths of light which it absorbs and reflects. Dominant light or dark colors can therefore bias the meter reading and exposure compensation is required. The first two images (top left) is taken as metered by the camera's meter. The dominant white has fooled the meter. In each of the five subsequent images exposure is increased by ⅓ stop i.e. $+⅓$, $+⅔$, $+1⅓$, $+1⅔$, $+2$ stops. An over-exposure of $+1⅓$ stops returns the snow to white but still retains some detail in the lightest areas of the image.

To illustrate how this works, let's walk through a real-life example of calculating an accurate exposure. The subject of this image is a light-colored wolf running in snow. The difficulty in calculating an exposure for this scene is the presence of no obvious medium tones and the effect of light reflecting off the snow.

To calculate the exposure, first selected spot-metering mode. Taking a meter reading from an area of snow gave an exposure value equal to 1/2000 second at f/8. Since, from experience, we know that this uncompensated exposure value will render the textured white snow as medium gray, applying +1.5 stops exposure compensation (textured white is 1.5 stops brighter than medium tone) allows us to whiten the snow but still retain detail. This gave a corrected exposure value equal to 1/500 second at f/8.

The result is a photograph of a wolf in snow that records the tones in the scene as they appeared at the time.

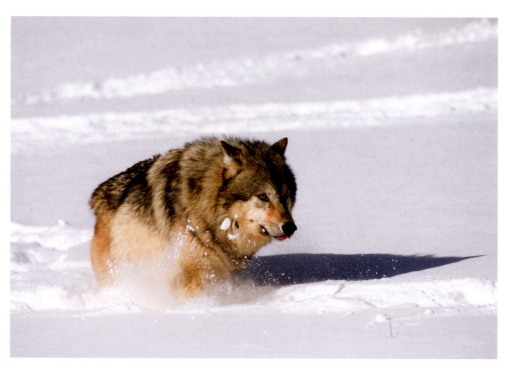

Spot metering from the snow and applying exposure compensation has enabled me to accurately record the tones in this complex scene.

Calculating Exposure Compensation

The true skill in mastering exposure is in determining what is and isn't medium tone. A useful habit to get into when learning how to assess tonality for calculating exposure compensation is to carry with you a Kodak Gray Card. This can be purchased from most large photographic retailers.

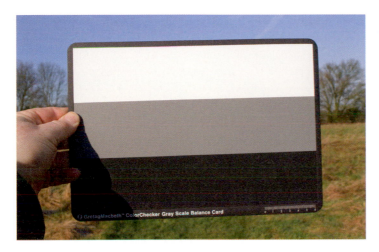

A gray card can be used to calculate exposure. The meter reading is taken from the card when positioned in front of the subject and in the same light.

On location, hold up the card and compare its tone to the tone of the subject. With the Gray Card as your reference, it is relatively simple to assess whether the subject is the same tone as the card, or lighter or darker. Once the subject's general tone is assessed, it is simply a case of deciding into which of the seven zones (boxes) it falls. For example, if the tone were darker than medium tone and closer to black it would fall into the box marked zone 3. If it's darker than medium tone but closer to medium than it is to black, then it must be dark gray.

Remember, this is a skill and, like any skill, gets easier with practice.

Visualizing the Scene

Once you have the idea of the Zone System and equating scene tones into zonal values, it is possible to visualize how you want an image to appear in print and set an appropriate camera exposure.

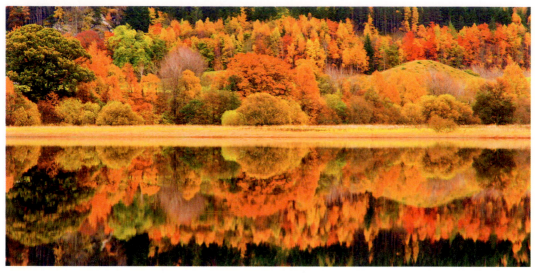

The skill in exposure is being able to accurately 'read' the tonality of different colored subjects.

In the examples we've given, we have talked about reproducing scene tones as they appear by 'placing' them in the corresponding zone, or box, and applying the appropriate amount of exposure compensation. But what happens if you want to reproduce a tone differently in print than it appears in real life? Let's look at another example. Say you are photographing a landscape scene in the middle of the day, when the sky is medium blue in tone. Now say you want to reproduce the sky as a light blue, closer to the tone it would be in the early morning. Using the Zone System, referring to the seven boxes we can decide to 'place' the medium blue sky not in zone 5, where it naturally belongs, but in zone 7, say, which would make it lighter in tone.

Zone 6 is 1 stop brighter than medium tone and by applying +1 stop of exposure compensation the sky would be recorded as light blue rather than medium blue.

Of course, by effectively overexposing the sky, all other tones would be lightened by the same value (unless some form of graduated filtration was used), which would need to be compensated for during post-capture processing – and this is exactly what Adams, Archer and all the photographers who followed did when shooting their spectacular and now iconic landscapes.

Exposure is a creature tool and the metered reading is only a guide. Here the center image shows the color of the sky when photographed as metered in camera. In the top two images the sky has been under-exposed by 2 stops (top left) and 1 stop (top right) respectively. Note how all the colors deepen. In the bottom two images the sky has been over-exposed by 2 stops (bottom left) and 1 stop (bottom right) respectively. The 'correct' exposure is not necessarily the metered exposure, but the one which reproduces the colors and tones as the photographer chooses for a particular image.

What is Composition?

Composition is design. Through composition we can arrange the different elements which make up an image, changing them in position and importance relative to each other. At first this may appear to be impossible. We can't add or take things out of a scene as a painter can, but if we use all the tools at our disposal the desired effect and strong composition can easily be achieved.

Good composition relies on our ability to isolate and marry the design elements in a scene.

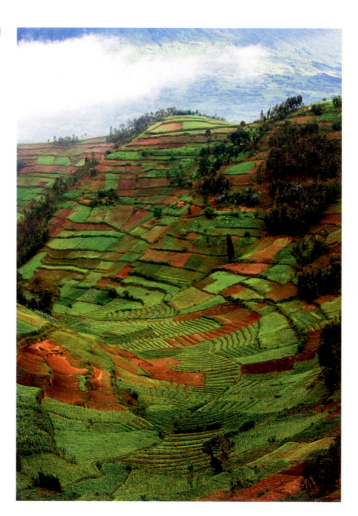

For a photographer, composition presents different problems to those of an artist. When artists paint, they start with a blank canvas. The painting evolves as the artist adds paint to the canvas, creating lines, shapes, patterns, colors and texture. If there is something in the scene being painted which is unsightly or unwanted, the artist simple omits it from the painting.

Let's imagine we're painting a landscape and running through that landscape is a line of electricity pylons. It simply doesn't matter, we can just leave them out. The artist has this flexibility and can change the scene, combine elements of different scenes, add clouds to a cloudless sky, paint a sunset in the middle of the day, etc. Reality is what you choose to make it and you can include whatever elements you wish because painting is an art of addition.

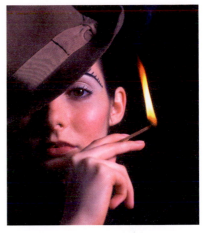

Composition is an art which takes time and practice to master. You must decide where to position the subject and what to exclude from the frame.

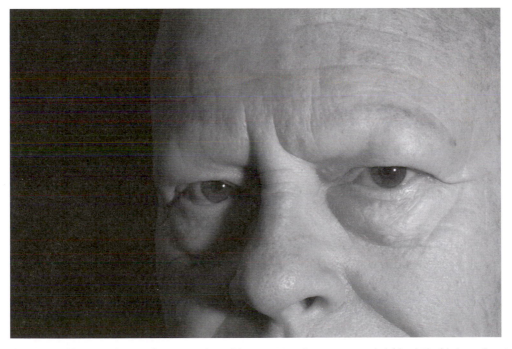

The tight crop adds impact to this image but an essential part of this composition is the empty space on the left hand side of the image. Space is an underused compositional tool and one which photographers are often reluctant to experiment with.

Photography is the opposite. It is an art of omission. When you pick up a camera and look through the viewfinder, the scene has already been painted. You simply can't choose to leave out the pylons, add the clouds or capture a sunset in the middle of the day. What you can do, and should do, as a photographer is to decide which elements and objects in the scene are important to your composition and which should be omitted. The important elements are the ones that you must now arrange into your composition. How you do this is the art of good composition and will determine the impact which your photograph has on the viewer.

In the end, painters and photographers arrive in the same place – an image that reflects a personal visualization. How we get there is an altogether different process and way of thinking and visualizing. Painters add pictorial elements, photographers must take them out. This is what composition is all about. This is how photographs are made.

From Snapshot to Masterpiece

Without considering composition we start from the snapshot – the image which simply records a scene or subject, the image that even a child can take with the simplest of cameras. This view of the world is rarely inspiring and usually lacks impact. Composition begins with deconstruction. The scene in front of you is no longer the majestic river sweeping up to the distant mountains, the woman walking through the field of flowers or the leopard sitting in a tree. This is a literal vision of literal subjects. To understand composition you must now view these instead as lines, shapes, colors, textures and patterns. These are the five building blocks, the five elements of design, that you must arrange through the process of composition.

This may sound a little grandiose but as we go further through the process of composition you will see how these elements fit together to create pathways around an image which either keep your attention within the frame (good composition creating impact) or allow the eye to wander out of it (poor composition making uninteresting images).

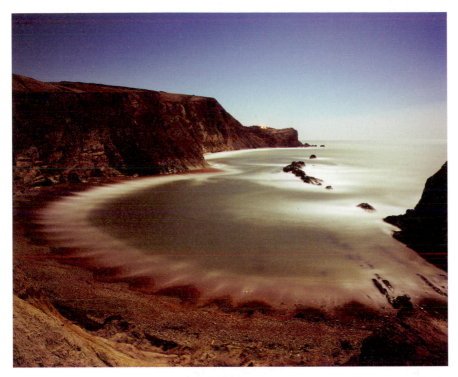

The strong compositional properties of this image are a result of careful framing to exploit the figure-8 shape in the landscape.

Having changed our scene in our heads from the literal description to one described by these five elements, we now have to use the tools at our disposal to change their position and importance relative to each other. In this process we will decide which elements to include in the frame and, more importantly, which to exclude. So how do we arrange these elements? First we must understand the tools and how they work. They are lens choice, viewpoint, aperture and exposure.

Lens Choice

Your lens choice, the focal length of the lens which you choose for a particular shot, determines firstly perspective. Wide angle lenses stretch perspective whereas telephoto lenses compress it. So the wider angle creates a more three-dimensional image and the wider your lens is, the greater the stretching, while telephoto lenses squash perspective towards two dimensions and the longer telephoto your lens is, the greater the compression.

Changing focal length of a lens does far more than simply change the angle of view. It changes perspective and how a subject relates to the other elements in the frame and the background. This sequence was shot at different focal lengths, moving away from the subject (the boat) as focal length increases, so that it occupies roughly the same position and size in the frame at each focal length. In the first shot, focal length 17mm, the distant second boat is only just visible behind the main subject. As focal length increases perspective is flattened and the second boat becomes visible.

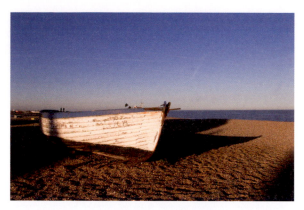

Focal length 17mm: full frame sensor equivalent = 27mm

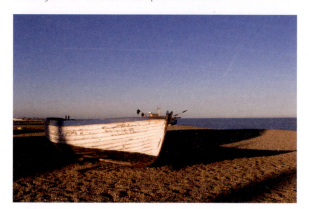

Focal length 24mm: full frame sensor equivalent = 38mm

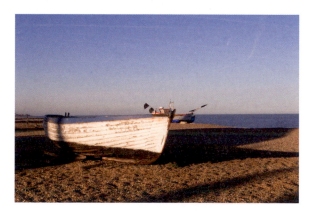

Focal length 35mm: full frame sensor equivalent = 56mm

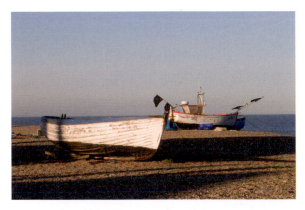

Focal length 70mm: full frame sensor equivalent = 112mm

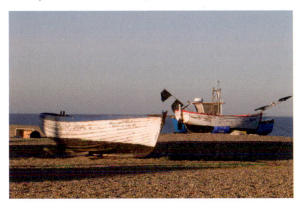

Focal length 105mm: full frame sensor equivalent = 168mm

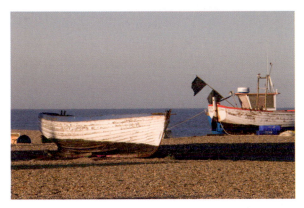

Focal length 200mm: full frame sensor equivalent = 320mm

Viewpoint

Perhaps the most important tool, and most underused with the advent of zoom lenses, is position or viewpoint. It's easy to stand in one place then just zoom in and out but this doesn't arrange the elements of an image relative to each other. Change viewpoint, however, and move to the side, higher or lower and you'll see that elements nearest to the camera move more in the frame relative to more distant ones. Suddenly the realization comes that we can rearrange a scene, not in the same way as an artist, but in a significant way that changes the way the five elements of design relate to each other. Combine this with lens choice and we can move elements in relation to each other, change perspective and choose to include in or exclude from the frame.

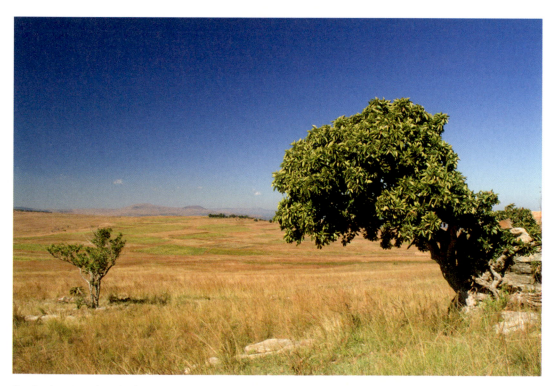

Changing viewpoint is a key tool in the composition and can be used to rearrange the relationship between different elements of a composition. This shot was taken at head height. The same focal length is used in all three shots.

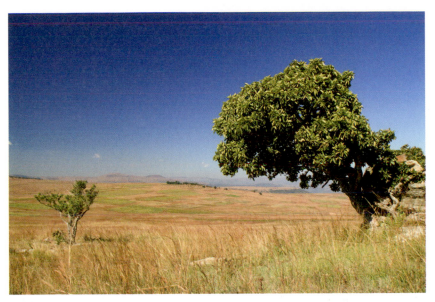

This second shot was taken from the same place but crouching down low to the ground. Note how the trees have moved higher in relation to the horizon but the shape of the trees remains similar.

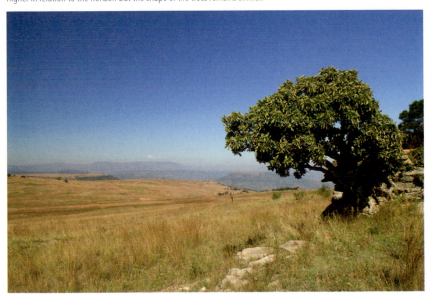

The third shot was taken at head height but from five meters to the left and slightly lower down the slope. Not only has the view of the horizon changed again but the main tree is now viewed from a different angle, changing its shape, and the second small tree has moved out of the frame.

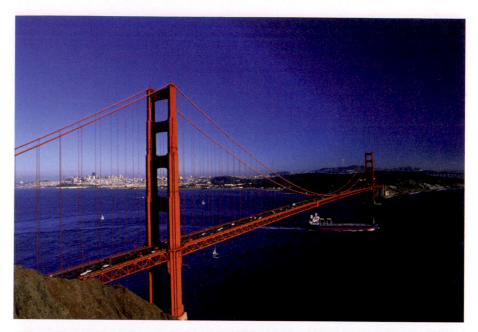

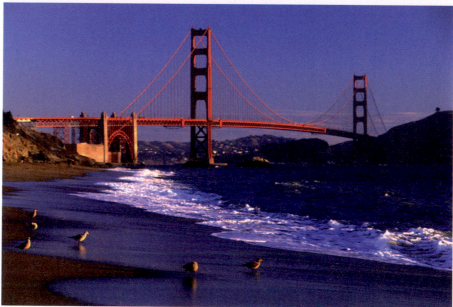

These four shots of the Golden Gate Bridge show how dramatically different images can be achieved simply by changing viewpoint. Experimenting with viewpoint is a vital part of composition.

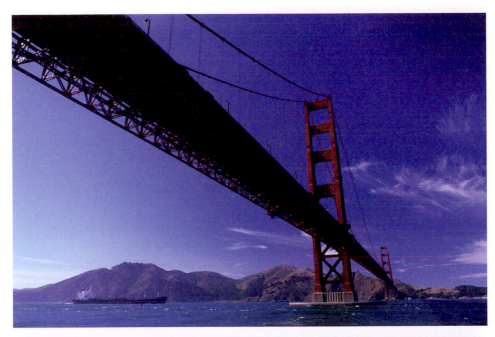

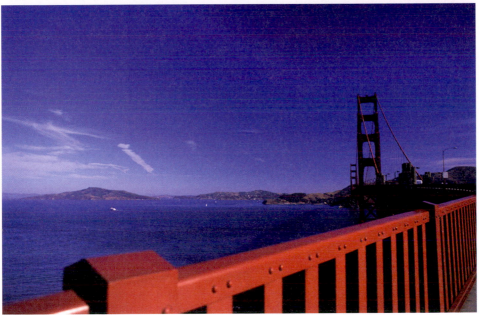

Aperture and Depth of Field

Aperture, combined with lens choice and distance from a subject, determines the depth of field – the distance in front of and behind the point of focus, which is in tolerable focus to the human eye. Think of it as range from front to back within an image which looks sharp, the sharpest point being the point of focus. Wider apertures (f/2.8, f/4, etc.) create a narrower depth of field whereas smaller or narrower apertures (f/16, f/22, etc.) create a much greater one. Depth of field, for any aperture, also decreases as focal length of your lens increases from wide angle to telephoto. Furthermore it decreases, even without changing the aperture, the closer you get to your subject.

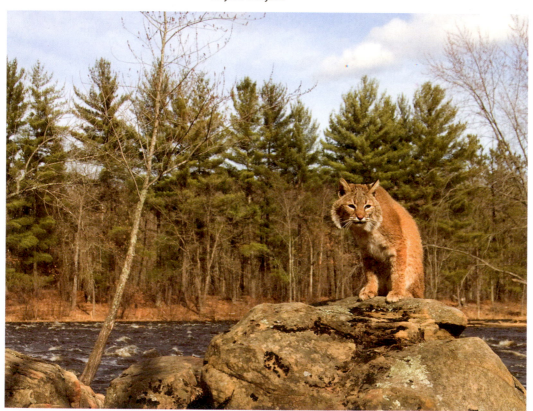

Although the subject is the same, the stories these two images tell are very different. In the image on page 44, the detail in the background is revealed to become a part of the picture and we create a sense of place. In the image on 45, background detail has been removed by narrowing depth of field, which isolates the cat from the background, creating a portrait image.

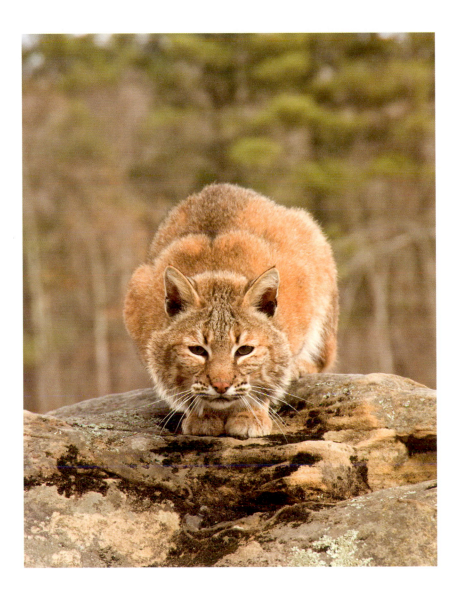

Exposure

Exposure can be used to darken or lighten an image. In doing so, everything within the image is darkened or lightened but by doing this we can decrease or increase the prominence of elements with the frame.

Using these Compositional Tools

Combining the five elements of design – line, shape, color, texture and pattern – with these four important tools – lens choice, position, aperture and exposure – at your disposal, we can change the appearance of any scene or subject quite dramatically. In other words, we can rearrange or design an image. This is composition.

Before going on to explain this in more detail in the following sections, it's important to understand the psychology of design and its role in composition. Photographs are essentially two-dimensional representations of a world which we see in three dimensions. Thinking of photography in terms of art, as opposed to a purely illustrative medium, in order for an image to be compelling, to have impact, we must replace this missing dimension with something else. That something else is emotion.

A photograph that elicits no emotional response will fail artistically. More importantly it is uninteresting and has little or no impact as a result. When we're making an image, the scene itself becomes more evocative because, in addition to what we see, the visual is supplemented by sounds and smells and even taste. So as photographers we need to use the visual information in the scene in such a way as to capture an essence of what we felt and experienced at the time the photograph was made. The tools we have to achieve this are the basic elements of design.

The Five Elements of Design

Line, shape, color, texture and pattern are all around us in both the man-made and the natural world. In fact they are part of the fundamental building blocks of life and the laws of physics. On a visual level they each have the power to evoke an emotive response and, in some instances, provoke a physical reaction. We can almost hear you saying, what are they on about, but it is for this reason that these elements are such important compositional tools. Line, shape, color, texture and pattern can be used visually in photography, either individually or in combination, to create or enhance mood and emotion within an image and, as in art, they can be very powerful tools.

Using the five elements of design – line, shape, color, texture and pattern – as compositional tools can add strength and impact to your images.

Line

Line is the most basic of the five elements. By its very nature it creates a sense of direction visually through an image. A horizontal line pulls the eye from left to right, or vice versa, across an image and can create a sense of width. A vertical line leads the eye upwards or downwards, emphasizing height or depth. Interestingly in both cases the direction in which the viewer reads the lines relates strongly to the direction in which your native language is written and read. Angled lines create a sense of depth and dynamism. This is further exaggerated with two lines at different angles, but in a similar direction, converge to create a sense of distance.

The position of the horizon determined which part of the scene receives the greatest emphasis.

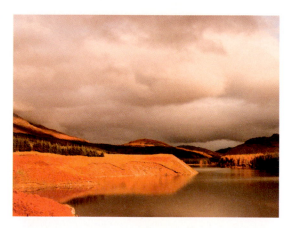

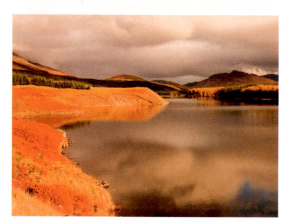

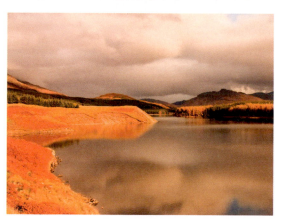

Line is also associated with the horizon and its position in the frame determines the portion of the frame that receives the greatest emphasis. For example, when the horizon line is positioned across the middle of the frame, equal weight is given to both halves of the picture. This equality forms a natural balance that creates a feeling of serenity and stasis. In photography this can be used to create a peaceful mood or misused to make an image look lifeless.

Positioning the horizon higher or lower creates either a dominant foreground or dominant background. A high horizon gives emphasis to the foreground – our eye travels into the frame and through this foreground to the horizon, creating a greater sense of depth. In contrast, a low horizon minimizes the foreground's importance within the frame whilst accentuating everything above it. With landscape images these would be 'big sky' shots.

In this shot, line is used, in combination with color, to create natural frames but they also define the subjects.

Objects are often used in photography to create a natural frame for a scene. When this is done the line of the horizon assumes more importance and tends to draw the eye sideways along the lines itself. Of course, lines don't have to be straight to evoke any of these responses and curved lines, although they tend to be less dynamic, still force our eyes along a directional route through the frame, creating a sense of visual energy.

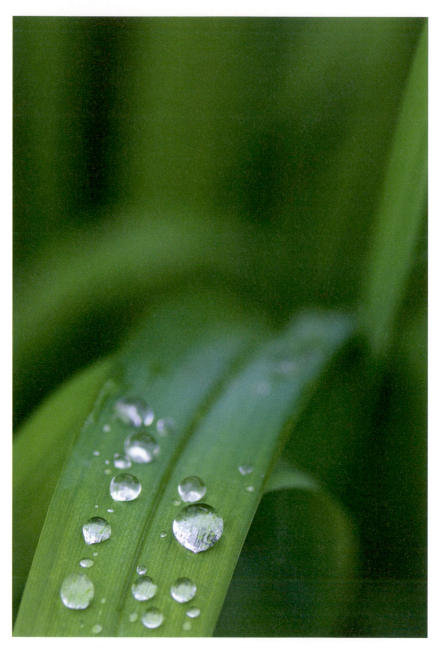

Lines which run into the frame from a corner accentuate a sense of depth in an image. The narrow depth of field used here focuses attention on the raindrops in the foreground.

Shape

Where lines meet they start to create shapes and it's fascinating how we as humans quickly identify shapes within a scene. Again, shapes are apparent and abundant throughout nature and evoke emotional responses in us. Triangles and polygons create a sense of strength and stability – a form of permanence. Pyramids, for example, are solid, immovable objects until you invert them. Then their component triangles lose their stability and become

Shape is a powerful element of design.

unbalanced as they stand precariously on a point. When viewed together in the same frame, any conflict between balance and imbalance creates a tension that heightens visual energy.

In contrast, circles, spheres and similar shapes, rather than creating direction contain the visual energy within their shape and draw attention to themselves. They can be very powerful if forming all or part of the main subject of an image but, when they aren't the main subject, they must be used carefully so that they don't dominate the frame or conflict with this subject for the viewer's attention. Two competing shapes can create a dynamic composition but they can also easily cause an image to lose impact by competing with each other.

Circles contain the information within them. Here, the model is emphasized by the shape of the ball.

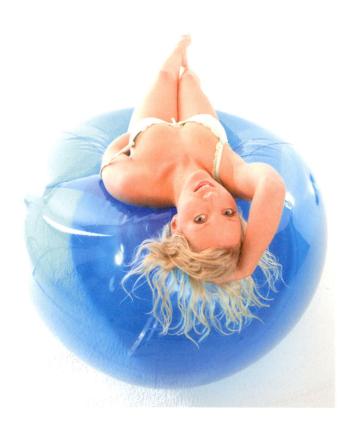

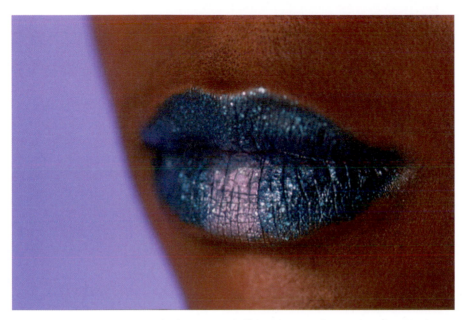

Color and shape define the image and, used with a narrow depth of field, make it very difficult to look anywhere other than at the lips.

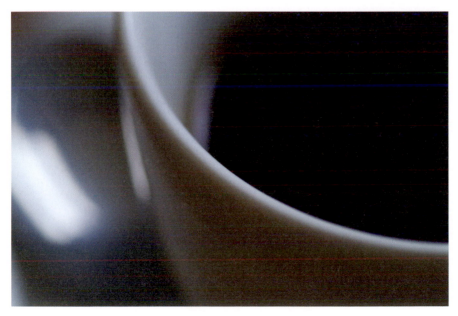

Shape and line interact to create an almost abstract image of a coffee cup.

Color

The third element, color, is immensely powerful and can easily dominate an image. The color of an object as we see it is determined by the wavelengths of light which its surface reflects or absorbs. Colors themselves create moods and are widely used in areas such as architecture to do just that. Colors tend to fall into either warm or cool tones. Blue is a cool color. It evokes tranquility and serenity. In contrast colors such as yellow and orange are warm, creating feelings of joy and happiness, whilst our response to colors like red is alarm, anxiety and a feeling of imminent danger. It's not just humans who respond in this way to color. The same principles apply throughout the animal kingdom and the broader natural world as a means of attracting mates or symbiotic partners whilst warding off predators and competitors.

Blue is a cool color, creating tranquility and serenity but also has the ability to make us feel cold.

Red and yellow are bold colors.

Orange is a warm color.

Combining colors can be used subtly to modify mood and also to create dimension and form. One of the most important color relationships, though, is that between complimentary colors – red and green, blue and orange, yellow and purple, for example. Combined in a photograph, these color pairings inject vitality and zeal to lift the composition. Red objects set against a green background will appear more vivid, while the different wavelengths of red and green light cause our eyes to respond with physical movement, adjusting focus, creating visual energy.

The study of color and our responses to it could be a chapter in its own right. Suffice it to say that for photographers, it's essential to have an understanding about how different colors make us feel and react so that we can use this in our compositions. Ignore

Yellow and purple are complimentary colors that work well together.

it and you could easily make mistakes when deciding how to frame a shot that, at the time, seem unimportant but later, when viewing an image, are glaringly obvious and change our response to that image, sometimes dramatically.

When shooting in black and white it's also important to understand how different colors reproduce as tones. With this understanding you can compose to make contrasts and shapes, as darker or lighter tones, from the colors themselves even in the absence of color.

The complimentary blue and orange colors in this scene resonate, making the composition stronger.

Red and green, complimentary colors, have a physical affect on our eyes that make images appear almost 3-dimensional.

Texture and Pattern

The final two elements of design – texture and pattern – are worth considering together as they are often closely linked. Interestingly, texture and pattern can frequently become the subject of a photograph themselves. Both are created from combinations of shapes and colors, and are apparent throughout nature, even down to the microscopic level.

The well defined lines in this image strengthen the composition.

By isolating a section of roofing, the composition of this image emphasizes the pattern of the tiles.

Pattern and line are used much more subtly in this image but are still an important part of the strength of the composition.

Texture is the subject of this image of bread laid out on a market stall.

Isolating this cross section of buildings in Morocco has created an abstract image that relies on shape for its compositional strength.

In photography, texture is created by the way in which light falls on the differing shapes and colors of surfaces. Even in the same material, a rough surface and a smooth surface placed next to each other will create an appearance of texture which can introduce a three-dimensional feel. Pattern is created by reoccurring shapes, colors or textures. Graphically they can be very powerful and also deceptive, again creating the appearance of three dimensions in a two-dimensional subject.

Texture and pattern really come into their own in close-up and abstract photography, and it is here that they most commonly become the subject of the image. However, this is not exclusively their most powerful use and many strong images use either or both, together or in contrast, to add striking visual elements to a composition.

Believe it or not, this is a public toilet. But careful composition has made use of line to create a powerful abstract image.

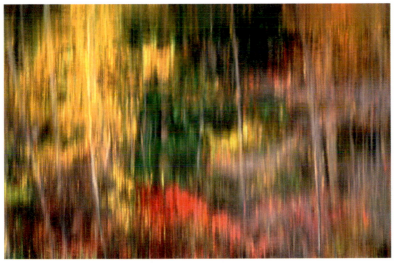

Line and color are the subject of this abstract image of autumn foliage reflected in a rippled lake.

With these five elements of design the photographer can create dimension, depth, emotion, mood, form and contrasts. They can become the image themselves or, used individually or in combination, be used to add interest or emphasize the primary subject of an image. These are the elements that define an image and ultimately determine our response to it.

Deconstructing the Image Space

Once you are aware of the five elements of design you can separate them and view them as the basic building block of composition. This process of deconstruction then allows you to decide which elements to include and how you want them to relate to each other. Again, this process should be done in your head rather than the camera viewfinder. Then you can choose viewpoint, lens focal length, aperture and exposure to capture the photograph as you've visualized it.

To help you with this in practice it's worth taking the time to look at and work out how each of the five elements can be used. Take them individually and focusing solely on a single element, observe what happens as you change position, change from a wide angle to a telephoto lens, use minimum and maximum aperture, and expose for both high key or low key. Take line as an example. Changing position can change a horizontal line, such as a line of trees, into a diagonal one, altering the apparent depth of the scene.

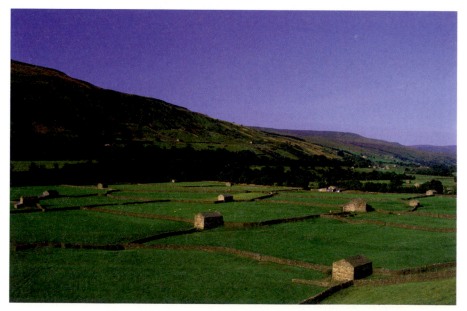

Within any scene there are many different images. The five elements of design give important visual clues as to where the strongest images can be found. All five elements are present in this scene. Using them we can deconstruct the scene to create an effective composition and an image with impact.

Lines, shape and color are used in this image of a small part of the original landscape. It is simpler but the composition remains untidy and ill-considered.

The final image is much simpler. Shot from a different viewpoint, the lines of the walls lead into the frame and towards the shape of the stone barn. The tracks also enhance depth and lead to the same place. A key element of this composition is the gap in the wall as this allows your eye to explore the background.

The Art of Omission

Getting used to the concept of photography as an art of omission, rather than one of inclusion, is the first step to improving your composition. Most photographers include too much in the frame and as a result the subject of their image is lost. The good shot is still in there, buried in that image, but the construction of the image itself doesn't make it jump out at the viewer. This is exacerbated by the fact that some viewfinders show slightly less than 100% of the final image.

Placing the subject centrally in the frame tends to create static compositions. This portrait is OK but doesn't have as much impact as it could have.

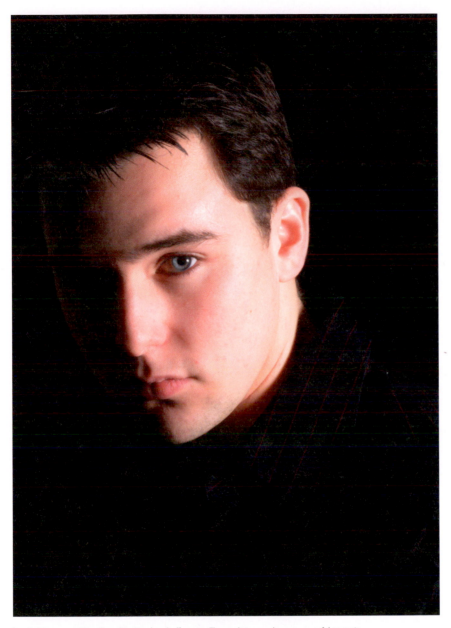

In a tighter composition the subject is placed off-centre. The result is a much more powerful portrait.

The objective with composition is to shoot the image you want full frame. This will then give you the highest possible resolution image to print. In this sequence we will show you how to improve the composition of this image by cropping out areas of the image but your objective should be to do this when you frame up an image in the viewfinder.

In the first image (top) the kingfisher is too central in the frame. It's posture suggests a direction to the image i.e. from left to right. Looking around the edges of the frame you will see that a reed in the top corner, plus another out of focus reed across the top of the frame, draws the eye away from the bird.

In the second image (middle) we have cropped some off the left hand edge of the frame. This has removed the reed in the top corner and decreased the area behind the kingfisher, effectively moving it off centre and to the left.

The reed across the top has been cropped out in the third image (bottom). As a result the kingfisher becomes much more the focus of the image. However the two reeds which catch the light on the left of the frame are still distracting.

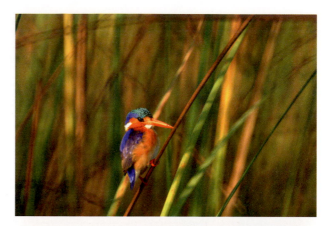

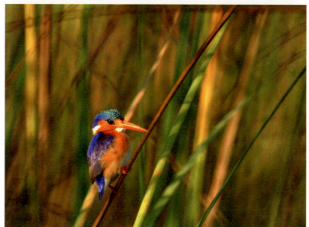

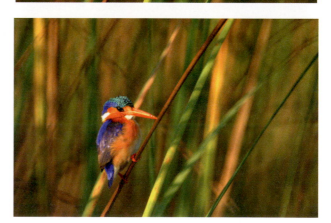

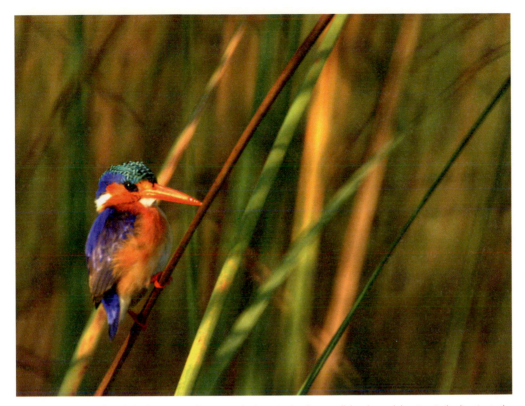

Removing these two reeds in the final image not only crops out the distraction but, because all the other reeds lean in a similar direction to the kingfisher, it adds extra impact. With composition, it's important to realize that the tiniest change can make a huge difference to an image and the impact it has on the viewer. There is one element here, though, which can't be cropped out. The end of the kingfisher's beak is directly in line with the reed it's sitting on and, because it's also in sharp focus, this is distracting. This can only be changed by adjusting viewpoint slightly before pressing the shutter.

A different approach to composition, and one that will help you move forward quicker, is to start small and work up rather than try to work with your chosen scene and then tighten it. Composition starts with the main subject of your image. Can you describe it? If asked what the main subject is can you describe one, and only one, thing? If you can't then you're not composing.

Decide what your main subject is first. A tree, a door, a person, an animal, a flower, a mountain, it doesn't matter. The same principles apply. Now start to include other elements in the frame, all the while checking to make sure that their inclusion or positioning doesn't detract from or compete with the main subject. Taking

The lack of color in this scene helps to emphasize other elements of design, in this case, line and shape.

this approach, an element of the composition that doesn't compliment the main subject can be excluded or repositioned.

In this process one thing which is most commonly disregarded, and is detrimental to creating strong images, will become blindingly obvious – the edges of the frame are just as important as the central area. A misplaced line, taking your eye out of the frame, or a splash of contrasting color in a corner can very easily cause the composition to breakdown. It is most probable that, in going through this process, you will find that you are getting much closer to your subject or using a longer focal length lens to achieve a stronger composition.

As a photographer you have all the tools you need to use to achieve better composition. They are lens choice, viewpoint, aperture and exposure as previously mentioned. So let's look at how these can be used creatively. The two most obvious ways of removing elements from the frame is to physically move or use a zoom lens to crop in camera. The latter of these is to

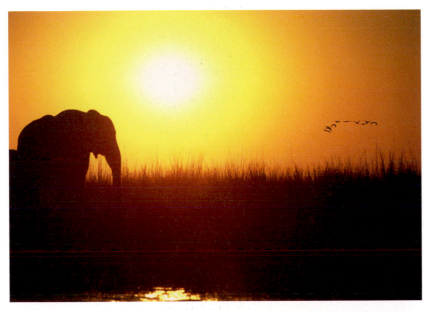

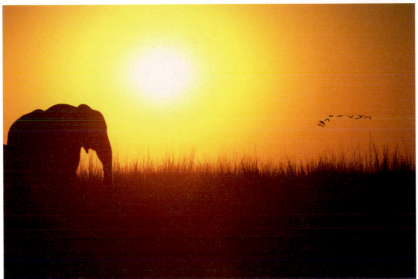

In the first image (top) there are three elements which diminish the composition; the water catching the light, the centrally placed horizon and a second elephant behind the main one which stops its rump from being a clearly defined shape. Cropping out the water at the bottom of the frame removes this highlight and also shifts the horizon downwards. A slight crop on the left-hand edge helps the shape of the elephant silhouette to stand out resulting in the much stronger second image (bottom).

When presented with a subject or scene, there are many different possible compositions. Which one we choose defines the image but also defines your personal styles. Presented with a scene like this would you choose to shoot a wide view, a panoramic one or look to isolate a detail.

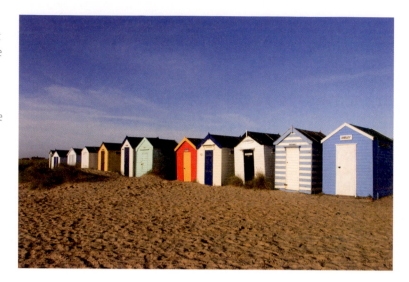

be discouraged because changing focal length also changes perspective. The relationship between objects at different distances from the camera changes with the focal length, as does the relationship between foreground and background. If this can be used constructively to improve the composition then this approach is perfectly valid but it should be a conscious decision rather than simply unconsidered.

Making the choice of changing lenses or changing viewpoint becomes a lot easier if you approach it from the standpoint of composing an image in your head first, rather than in the camera viewfinder, or worse, on the LCD screen. At first you'll find this approach challenging but as your composition improves it will become instinctive, freeing you up to make creative decisions first then choosing the appropriate tools to capture a visualized image. Whatever way you find most comfortable though, don't take the approach that an image can be cropped on a computer screen later. This is not composition!

Aperture is often overlooked as a compositional tool but it is very powerful if used well. It surprises many photographers when they learn that aperture alone, when selected carefully and in combination with viewpoint, lens choice and distance from camera to subject, can be used to omit a subject from the frame without moving or realigning the camera. Our eyes use focus and

In the first shot (left), the focus is on a single beach hut and the angled view gives depth to the image. By showing part of the huts on each side there is no finite limit to the composition and the viewer's perception is altered leading to the assumption that these are just three of a row of even more huts which are out of frame. The straight on view in the second shot (right) is much more graphic but two-dimensional. In this instance the composition is strong but the image is ruined by the sun flare on the right of the building. This could have been reduced or removed using a polarizing filter and/or slight change of viewpoint.

depth of field to order objects within our field of vision. By shifting focus we are able to emphasize or give importance to one object over the others. However, the depth of field afforded by the human eye is enormous compared to that of photographic lenses at the wider apertures. We tend to focus our attention on the sharpest objects and attach less importance to the out of focus ones and this can be used to good effect in photography. Using a narrow depth of field, we can blur distracting detail thereby diminishing its prominence in the frame and importance in the overall image. If we think of this in purely composition terms, aperture gives us the means to control the appearance of lines, shapes, colors, textures and patterns in an image, to emphasize

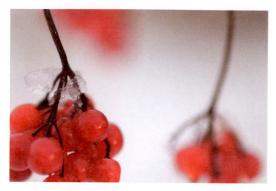

This sequence of images illustrates how aperture can be used to change a composition. The four images were shot at f2.8, f5.6, f11 and f22 respectively. Note first how the background is completely featureless in the image shot with the widest aperture f2.8, whereas at f22 distant branches and berries add tones and color to the background. There is also a marked difference in the second bunch of berries as aperture narrows. The third bunch, which are furthest from the camera, have almost disappeared at f2.8 and appear only as an undefined red shape. At f22 they are not in sharp focus but are clearly another bunch of the same red berries. Careful use of aperture can make a distant subject disappear into the background.

or de-emphasize them as a contributor to the overall image composition and control the impact of an image on the viewer.

This also highlights one of the issues that photographers have with improving their composition. SLR cameras hold the lens at maximum aperture so that the photographer has as bright an image as possible in the viewfinder to aid focusing and composition. In doing so they provide a bright image but also only show the depth of field at maximum aperture. So, unless the chosen aperture for a shot is the maximum one, the final

image will have a greater depth of field than the image in the viewfinder, and the smaller the shooting aperture, the greater the difference. This is not usually a problem with most wide-angle shots, but when using a telephoto lens and getting close to a subject, the final image can look dramatically different, as details which were not visible in the viewfinder suddenly become prominent in the photograph. For this reason it is essential to have a DSLR with a depth of field preview button so that you can check before pressing the shutter.

In many images our objective is to capture as much detail as possible, from the darkest shadow to the lightest highlight. In other words we try to maximize the tonal range of an image. In some instances, though, we could also use exposure to control the composition by deliberately overexposing to blow out

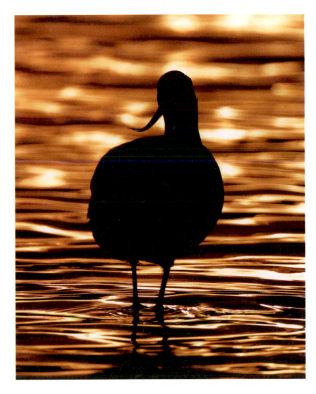

Removing detail from the birds feathers helps to emphasize its shape.

highlight detail where it isn't wanted, giving a featureless white or, going the other way, deliberately underexposing to darken shadows to featureless black. With slight exposure compensations the effect on composition can be very subtle, but overexposing (high key) and underexposing (low key) can be used in a more exaggerated way to achieve more dramatic effects.

In using all these tools we, as photographers, are making creative decisions that affect the appearance of the final image. It's important to realize that there's no right or wrong way to be creative. There are simply different ways, each contributing to

By over-exposing the background in this scene and reproducing it in black-and-white, the shape, pattern and texture of the giraffe are emphasized.

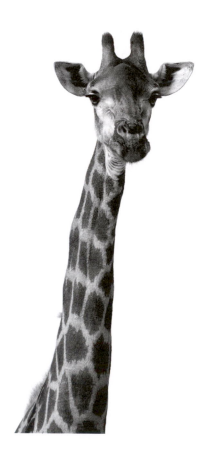

that image, and how we use them determines how successful our image is. It also determines our individual photographic style. There is no point in photography if we all take the same image so don't be afraid to experiment with the tools at your disposal, but make these decisions consciously and understand each one's contribution to the whole.

If we could give you one piece of advice which will contribute to you composing your images successfully then this would be 'slow down'. Speed is the enemy, unless you are one of the great photographers who can see, compose and shoot in a fraction of a second. For all but a few this ability comes with experience. Shoot less but shoot better – you will save yourself endless hours in front of a computer trying to rescue your images. One well-composed image is better than 100 average ones any day and the feeling of knowing you've got the shot without having to check at the time of shooting is a very rewarding one.

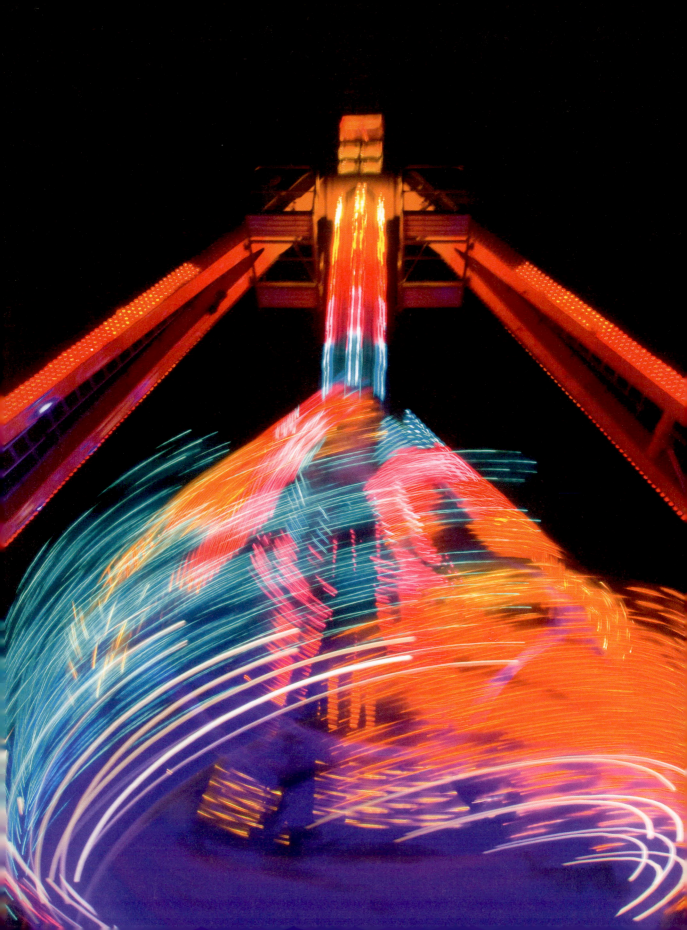

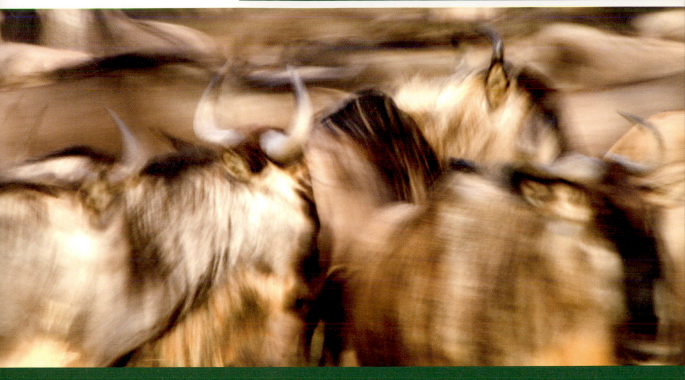

Interpretation and Expression

The Camera as a Creative Tool

The old saying that 'A camera is nothing more than a light-tight box' is no longer true anymore, especially the DSLR – a digital camera is a relatively powerful computer that in itself has far greater impact on image quality than a film camera.

Cameras – a body and a lens – are to a photographer what brushes are to a painter. They are the tools by which the photographer paints light onto the sensor and creates an artistic impression of the scene before the photographer. The ability to wield these tools in creative and imaginative ways, as much as technical proficiency, is what enables one photographer to stand out from another.

Lenses are the artist's eyes. They enable us to focus our vision, to pick out the individual components within a scene that together form a view. Lenses enable us to alter our perspective, to change the way we see the world around us.

The shutter is the controller of 'brushstrokes'. A long shutter speed equates to the fast movement of a paintbrush, blurring detail and creating a sense of movement. Fast shutter speeds are the equivalent of slow, careful strokes of the brush, revealing detail, creating sharp, well-defined edges.

Lens aperture can be described in terms of the size of the paintbrush. A wide aperture is like a large brush, making minute detail harder to control. A small aperture, like a small brush, enables the artist to create sharp detail even of the remotest points.

The bottom line – however many pixels the manufacturers manage to cram onto a sensor, and however many additional functions, knobs, buttons, dials and menu options they add – is that lenses, the shutter and lens aperture are the most important part of the camera, and a failure to understand them fully is what holds many a photographer back.

Lenses and Perspective

Your choice of lens will determine spatial relationships between objects on different planes. This is because, when the focal length of a lens is changed by zooming in and out, or by changing between prime lenses, not only is the angle of view (how much of the scene is covered by the lens) altered but so too are the perceived distances between objects.

The term 'spatial relationships' refers to how objects at varying distances in the scene relate to each other in the image frame. For example, an object in the foreground can appear far from the background or on the same plane as the background, depending on how they are photographed.

With a standard focal length lens (equivalent to around 50 mm on a digital camera with a full-frame sensor) spatial relationships appear in print much as they do when viewed with human vision. This is because the angle of view of human eyesight is similar to that of a 50 mm lens. When focal length is altered towards the longer, telephoto end (70 mm and above) the space between objects is squashed, making objects appear to be

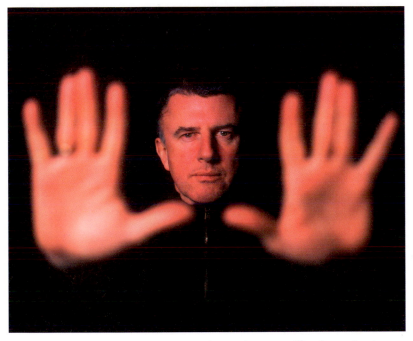

Lens choice determines the spatial relationship between elements of an image at differnt distances from the camera. Here the hands, which are closer to the camera, appear bigger than the head and aperture has been used to make the head into subject of the image.

closer together than they are. The effect of this is shown clearly in the image of the giraffe, (page 74).

In this photograph the animal appears to be standing in the shade directly under the acacia tree. In reality, it is about 100 yards back from the tree, in open ground. The use of a long telephoto lens (800 mm) has caused the space between the two objects to close, creating a much flatter scene.

At the opposite end of the scale, a wide-angle lens (35 mm and below) stretches the apparent distance between objects in the frame, giving a greater sense of space. This is one reason wide-angle lenses are suited to landscape photography, where creating a sense of a wide-open place is often the photographer's aim.

The choice of lens or focal length should be dictated by how you want to portray the relationship between objects in the scene – close together, far apart or somewhere in between.

This sequence simply shows the angle of view and magnification achieved with different lenses. The yellow tractor is in the centre of each frame; 17 mm (top left), 35 mm, 70 mm, 105 mm, 200 mm and 500 mm (bottom right) respectively.

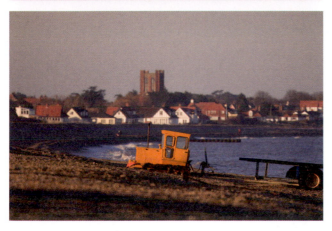

Angle of view characteristics

The focal length of a lens remains the same irrespective of the format of camera it is attached to. However, the angle of view of the lens changes, creating an impression of a longer or shorter focal length. Use the table below to ascertain the angle of view characteristics of different focal length lenses used with different sized sensor formats.

Format	Full-frame digital (36 × 24 mm)	Medium-format digital (48 × 36 mm)	Nikon DX (∼24 × 16 mm)	Canon small-format (22.2 × 14.8 mm)	Four-thirds (18 × 13.5 mm)
Effective magnification factor	1×	0.6×	1.5×	1.6×	2×
Equivalent focal length	20 mm	12 mm	30 mm	32 mm	40 mm
	24 mm	14.4 mm	36 mm	38.4 mm	48 mm
	28 mm	16.8 mm	**42 mm**	44.8 mm	56 mm
	35 mm	21 mm	52.5 mm	56 mm	70 mm
	50 mm	30 mm	75 mm	80 mm	100 mm
	70 mm	42 mm	105 mm	112 mm	140 mm
	80 mm	48 mm	120 mm	128 mm	160 mm
	105 mm	63 mm	157.5 mm	168 mm	210 mm
	135 mm	81 mm	202.5 mm	216 mm	270 mm
	180 mm	108 mm	270 mm	288 mm	360 mm
	200 mm	120 mm	300 mm	320 mm	400 mm
	210 mm	126 mm	315 mm	336 mm	420 mm
	300 mm	180 mm	450 mm	480 mm	600 mm
	400 mm	240 mm	600 mm	640 mm	800 mm
	500 mm	300 mm	750 mm	800 mm	1000 mm
	600 mm	360 mm	900 mm	960 mm	1200 mm
	800 mm	480 mm	1200 mm	1280 mm	1600 mm

How to use this table: a lens used on a digital camera with a full-frame sensor shares the same angle of view characteristics as it would if used on a 35 mm film camera. However, when the same lens is used on a camera with a smaller or larger sensor format its angle of view characteristics change. For example, a 28 mm wide-angle lens will give an angle of view equivalent to a 42 mm standard lens when used on a Nikon camera with a DX-type sensor (highlighted in bold type). Here, the Nikon DX and Canon small-format sensors are examples of the APS-C (Advanced Photo System type C) sensor format.

These two images show the relative difference in image size at the same magnification when the image is captured on a full frame chip (top) and a smaller Nikon DX chip (bottom)

Focus, Aperture and Depth of Field

In photography there is only one plane of focus. Everything either side of that plane, whether nearer or further away, is out of focus. This makes selecting focus distance an all-important choice. With some subjects the focus point is more obvious. In portrait photography, for example, a photographer will almost always focus on the subjects' eyes. The same goes for wildlife. With other subjects, optimum focus distance is less apparent – landscape photography being an obvious example. When looking at a landscape scene where compositionally important objects are as far spread as the near foreground to infinity focus, on which plane should focus be set?

The complicating factor relating to focus is depth of field – a phenomenon that occurs due to the fallibility of human eyesight. When a lens is focused, light rays come together to form a point. Away from the point of focus, light rays form circles. In terms of the majority of digital SLR cameras, when these circles are smaller than 0.03 mm in diameter, humans are unable to distinguish them from points, making them appear sharp, or in focus. This is how depth of field works. If you can make all the circles created by the diverging light rays smaller than 0.03 mm then the whole scene, from foreground to background, will appear sharp. Conversely, to blur object detail, to hide it from the viewers' eyes, these same circles need to be larger than 0.03 mm – and the larger they are the more blurry detail will appear. Lens aperture controls the size of these circles.

Lens Aperture

Lens aperture controls the quantity of light passing through to the sensor by adjusting the size of the hole created by the diaphragm in the lens. A doubling or halving of the area of the hole equates to a ± 1 stop change in exposure.

The numbers used to denote aperture size appear at first glance to be meaningless and confusing. They aren't. The f/number (or f-stop) numbering system is a ratio relating the focal length of the lens to the diameter of the diaphragm opening. For example, the f/number 2 (f/2) equates to a ratio of 2:1, i.e. the focal length of the lens is twice the diameter of the diaphragm aperture.

Reading f/numbers as fractions also makes sense of the 'small number, big hole' puzzle. Many novice photographers often wonder why a large aperture has a small number (e.g. f/2), while a small aperture has a large number (e.g. f/32). The answer is that f/2 actually means 1/2 and f/22 means 1/22. One half is bigger than one 1/22 just as the aperture at f/2 is bigger than the aperture at f/22.

In physical terms, the f/number scale relates to the area of the aperture. For example, a 50 mm lens set at f/2.8 has an area of 250 mm^2, while at f/4 the area is 123 mm, essentially half the area. At f/2 the area is 491 mm^2, or in other words double that of f/2.8. Scientifically, then, the f/number system begins to make more sense, a 1 stop change in f/number equating to a doubling or halving of the area of the aperture and, by association, the quantity of light reaching the sensor.

Depth of field decreases with aperture, increasing focal length of lens and distance from the subject. Here a telephoto lens at f2.8, positioned close to the subject, has been used to produce a very narrow depth of field. Only the front of the eyeball is in focus.

Something to consider when setting lens aperture is that lens performance is at its maximum when mid-range apertures, such as f/8–f/16 are used. When very small or large apertures are set, lens performance is diminished. For example, while setting an aperture of, say, f/22 or f/32 may seem an ideal way of increasing depth of field, a better solution would be to use a larger aperture (e.g. f/11) in conjunction with the hyperfocal distance focusing technique described on page 87.

Emphasis and Aperture

Depth of field is important because it defines in the image space the point of emphasis. Humans are visual creatures; vision is our primary sense. When we see an object that is, or appears to be, in focus it stands out and we take notice of it. However, when an object is blurred or obscured, we lose interest in it to the extent that when it is completely obscure we tend not to see it at all.

Translating this observation into photographic terminology, objects that appear sharp are emphasized and draw our attention. Objects that are blurred lose emphasis and we tend to treat them as secondary. Therefore, by selective use of focus and depth of field it is possible to dictate what objects the viewer of an image sees and, by degrees, in what order.

This goes to the heart of photographic composition. Unlike painting, which is an art of addition – a painter starts with a blank canvas and adds things to it – photography is an art of omission. When you point your camera at a subject or scene your picture is already 'painted', with all its good points and bad. The trick in photography is to define what elements in the scene are important to the composition and which are not. Those that detract from the subject, cluttering the image space, must be removed, omitted. One of the tools at your disposal to achieve this is depth of field.

By blurring image detail with a very narrow depth of field, it's possible to hide unwanted pictorial information that is otherwise impossible to remove physically (by cropping or narrowing the angle of view of the lens).

Hyperfocal Distance Focusing

Hyperfocal distance focusing is a means of gaining the maximum amount of depth of field. For example, imagine a scene where the closest visible object in the scene is 20 feet from the camera and the furthest object is at an effective distance of infinity. Now, with the camera focused at infinity and the lens set to its minimum aperture, say that depth of field stretches from 30 feet to somewhere beyond infinity. In this example, the closest object, which is 20 feet from the camera, would be blurred as it lies beyond the range of depth of field, which we have determined in this hypothetical scenario to be from 30 feet to beyond infinity.

Even with the lens already set to its minimum aperture, it's possible to bring the foreground object that is 20 feet away, within range of acceptable sharpness by using hyperfocal distance focusing. This works because hyperfocal focusing effectively enables photographers to alter the position of the zone of acceptable sharpness (depth of field).

This technique is best described using a visual reference. Referring to the illustrations (pages 88–89), notice how in this example, depth of field extends beyond infinity. The extent of depth of field that lies beyond infinity is in effect wasted because it will appear sharp anyway. So, what we need to do is position the furthest point of depth of field at infinity, thereby bringing the nearest point closer. Adjusting focus from infinity (its current setting) to the distance at which depth of field begins (the hyperfocal distance), which in this example is 30 feet, will make this happen.

Using hyperfocal distance focusing, in this example, brings forward the start of the zone of acceptable sharpness to a point halfway between the camera and the hyperfocal distance – in this example 15 feet. Enough to bring the object closest to the camera (given as 20 feet) within the zone, making it appear sharp.

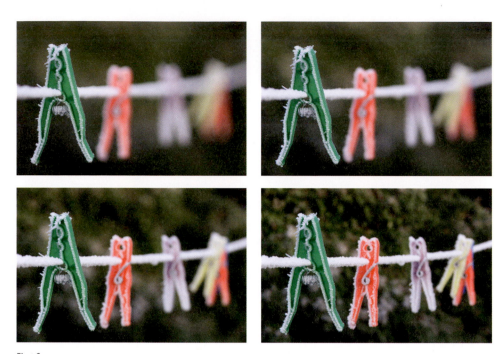

First Sequence

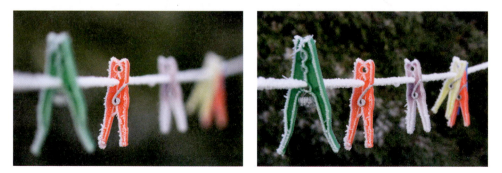

Second Sequence

Hyperfocal distance can be used to give control over which elements in the frame reproduces in focus or soft. To do this accurately it may be necessary to vary the point of focus within an image. In these four sequences, a different point of focus has been used. In the second and third sequences the first shot is taken at f2. 8, and the last at f22. Sequences one and four, the second image is shot at f5. 6, the third at f11 to show the progression of depth of field changes.

Third Sequence

Fourth Sequence

In the first sequence, focusing on the first peg, it isn't possible to bring all four pegs into focus even when shooting at the smallest aperture f22. In the second sequence, focused on the second peg, the first peg is in focus at f22 and the last peg also just comes into focus at this aperture. In the third sequence, focused on the third peg, it is not possible to bring the first peg completely into focus at any aperture and the same is true in the fourth sequence, focused on the last pegs. Note also how the bushes in the background come more and more in focus as the focus point is shifted backward, including them in the range of focus.

By shifting the point of focus in a composition, sometimes away from the main subject, and selecting the appropriate aperture, the range of focus in any image can be controlled precisely.

Incremental Exposure Adjustments

Most cameras these days enable shutter speed and lens aperture to be changed in increments of 1/3 or 1/2 stop. Where this is the case, then the effect on exposure is not a doubling or halving but is relative to the incremental change. For example, reducing shutter speed from 1/60 to 1/45 second represents a 1/2 stop increase in exposure duration, equating to a 1.5 times increase in exposure.

The camera metering system calculates exposure as mid-point gray assuming a good balance between light and dark tones in an image. Where the image is predominantly light (as in this example) or dark tones, the metering system will give a false reading because it is still trying to calculate an exposure for these tones based on mid-point gray.

The first image (top left) shows how the image would reproduce when shot as metered in the camera. Each subsequent shot has been over-exposed by +⅔ stop (top right), +1⅓ stops (bottom left) and +2 stops (bottom right) respectively. In this example the third shot (+1⅓ stops) is closest to how this winter landscape looked but a closer look shows that highlight detail is being lost so the second shot (+⅔) gives a better end result. This is a good example where bracketing exposures would be advisable and an additional exposure at +1 stop would be a good idea.

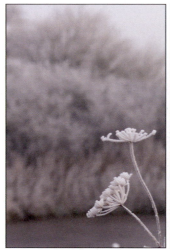
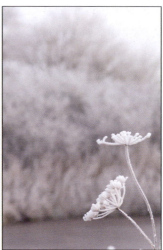
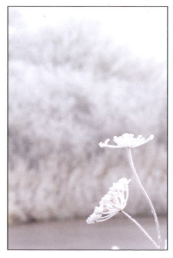

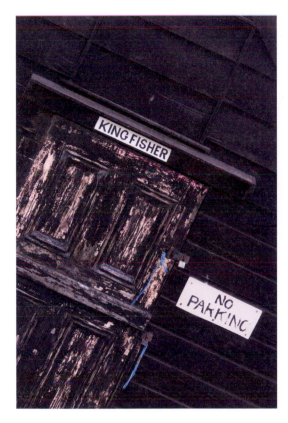
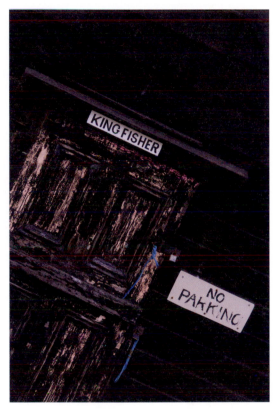

With predominantly dark tones an image must be under-exposed to restore the dark tones. In the first image (left) the camera's meter has been fooled and the scene is over-exposed. The second image is under-exposed by 1 stop to give a more accurate exposure.

Movement and Shutter Speed

The shutter controls the duration of exposure, which in turn determines how time appears in an image. Shutter speed timing is measured in seconds and fractions of seconds, denoted by shutter speed values, which, in a typical camera, range from between 30 and 1/4000 second (additional settings, such as Bulb and up to 1/8000 second may be possible). Each doubling or halving of shutter speed equates to a 1 stop change in exposure. For example, by reducing shutter speed from 1/500 to 1/250 second, the exposure duration is doubled. Conversely, increasing shutter speed from 1/250 to 1/500 second reduces exposure duration by half.

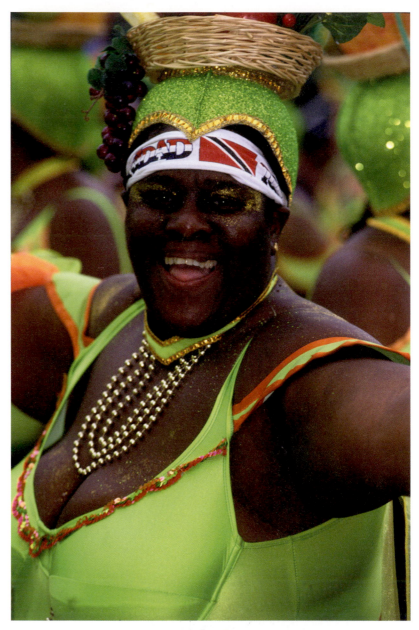

Dark skin tones present the photographer with a potential exposure problem in much the same way as the dark building on page 93, through in this shot less exposure compensation (−2/3 stop) was required because the darker tones don't dominate the frame.

The Appearance of Time and Motion

In photography, time can be frozen in order to reveal detail and form or it can be blurred to create a sense of movement and motion. For example, a moving animal can be photographed with a (relatively) fast shutter speed, the resulting image showing a well-defined outline of its posture, the look on its face and in its eyes, the ruffles in its fur, etc. Alternatively, using a slow shutter speed, these elements of the image can be hidden and replaced with a blur of rushing legs and heaving bodies, where

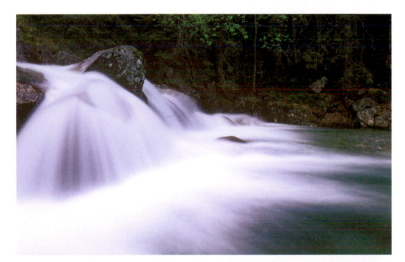

A slow shutter speed allows any moving elements to blur giving the impression of movement or speed — the slower shutter speed, the more the motion blur. In this waterfall shot the shutter speed of 5 seconds produces the soft effect in the water while the static elements anchor the image.

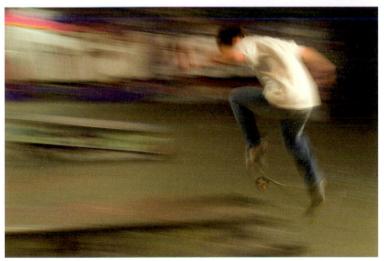

A slow shutter speed to produce movement blur, combined with camera movement, results in blur throughout the frame. Here the camera has been panned during the exposure creating the horizontal banding behind the movement blur of the skateboarder.

A faster shutter speed freezes the appearance of time, revealing detail.

outlines are less distinct and an atmosphere of motion pervades. Neither composition is right or wrong, simply different ways of interpreting the same subject.

Playing with Time and Light

Photography really starts to become interesting when we start to play with both time and light – and a DSLR is a perfect tool to experiment. To do this you will need to leave behind you any thoughts of using the camera in a conventional way and start to visualize the effects of stretching it to the limits of its capabilities. We tend to think of light as just being 'there'; however, artificial light, in particular, is often changing and moving. Think of traffic lights, a bus at night, a fairground or fireworks, for example. These present us with different issues to natural light in that we are trying to capture bright light against a dark or black background.

Let's start be considering a static light at night. Here, the light is bright and contrasts strongly with a dark background. It is unlikely, with this high contrast, that we'll be able to retain detail in both the bright light and the dark background so let's use this and assume that we'll lose the background anyway. This allows us to concentrate on capturing the lights so that colors reproduce brightly without burning out. It's a process of trial and

error to begin with but once we've determined the exposure for a specific light source, we can start to play with this exposure and color balance to change the intensity and color of the light. It's really important to approach this with an open mind and be prepared to experiment. It doesn't matter if a shot doesn't work as long as you get the principles of how these two factors alter the light then persist until you get the shot you want.

Now let's look at a traffic light. How do we capture all three colored lights in the same image? The answer is to keep the shutter open for long enough to allow the lights to complete their sequence. To do this without camera shake or movement we'll need to put the camera on a tripod, or other support, and use a cable release. We'll also need to work out how long the sequence takes to complete. There is a balancing act here in that with so many of these shots we need to gauge exposure with the key factor being shutter speed. This means using both aperture and ISO to ensure that the calculated shutter speed can be achieved. With traffic lights we have some flexibility because the sequence is repeated and the structure is fixed or static, so we could achieve the shot over more than one sequence if necessary, but this is not always the case.

Calculating shutter speed for the movement affect which you want to create is an important element in capturing motion blur. Taking a photograph of traffic lights at night is easy but what shutter speed would you need to capture all three lights — red, amber and green — in the same image?

There's no one easy answer because each set of traffic lights is sequenced depending on the traffic flow through that particular junction. Try this simple experiment. If is not as simple as it seems especially when you realize that one or more lights will be over-exposed if you get the timing wrong.

How was this effect achieved? The 'oblivion' sign is made of lights which flash on and off for each individual letter and the arrows, but these lights are only ever on at the same time momentarily. The blurred background is created by a well lit fairground ride which swings like a pendulum. The effect was created by working out the time for the light sequence on the sign to light every element then timing the shutter release so the lit pendulum swung through the frame at least twice during the exposure.

The same pendulum fairground ride, that was used to create the background to the image on page 96, is shot here from a different angle and at a point where it is rotating rather than swinging. The support aims are static so don't show any motion blur.

The next stage is to apply these principles to something that's moving. By allowing a longer shutter speed we can create a sense of movement, as with the example of the wolf on page 30, but can concentrate solely on how we want the lights to reproduce without having to worry too much about background detail. A moving bus at night is a good subject to practice on because you know there'll be another one along soon and a few trial runs will quickly give us an idea of how long we need the shutter open for to create dynamic movement. We need to balance this too, so that we get the appropriate amount of movement for the composition to work without having the shutter open too long, so that the image loses form and becomes totally abstract splashes of light. Abstract shots can work but often having some element within the frame that is either recognizable or fixed, to act as an anchor for the movement, can add more impact.

You should be getting the message here that this type of photography is about experimenting to get the desired effect. There is no right or wrong way to do it. You can reduce the amount of trial and error by having a clear idea of the image you want to achieve, estimating the speed of the subject and the time needed to pass through the frame (or part of the frame) before trying a shot. The other factor to bear in mind is relative speed. The closer you get to a moving subject, the faster it appears to move through your field of vision. This also depends on whether the subject is towards (or away from) you or perpendicular across the frame.

The London Eye takes 30 minutes to complete one revolution. So how long an exposure would be required to make it reproduce as a complete circle of light? The answer is suprisingly short because it only requires enough time for one individual pod to move to the position of the next one during the exposure to create this illusion. Count the number of pods then divide 30 minutes by this number and you have a guide to the shutter speed required.

Your first guess will allow you to estimate shutter speed then start to refine it. Take the London Eye (the biggest Ferris wheel in Europe) at night as an example. This moves relatively slowly, especially when viewed from a distance. How do we make an image of the London Eye that is a continuous circle of light? It's much easier that you might imagine and by simply measuring the time it takes for one illuminated pod to move to the position of the one in front of it you can join the circle. This time is our minimum shutter speed, and anything longer just produces more streaks and less identifiable moving elements.

Fireworks make spectacular photographs if you get them right. They work especially well if the sky is clear because there is no background to catch the light. When it's cloudy or misty, this can reflect some of the light from the fireworks back towards the camera and lighten the background, reducing contrast. This is especially true when keeping the shutter open long enough

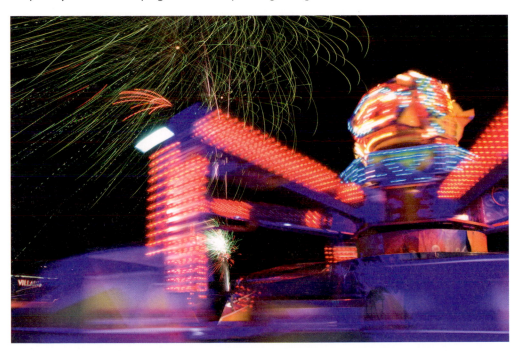

Being creative with light and movement is often about timing. In this shot the shutter release was timed so that the movement from the fairground ride coincided with the fireworks in the sky. The shutter speed was calculated to show some movement but not enough to create an indistinguishable blur of light. The position of the ride within the frame is also important as this will either draw the viewer into the image or, if badly positioned and timed, block the viewer from exploring the rest of the frame.

to capture several fireworks exploding within the frame. Again, we start with a degree of trial and error, based on a best guess of the shutter speed needed to achieve the desired effect. If the shutter speed is relatively short you are likely to catch the initial explosion of the firework but only short light trails from it. As these are the most striking part then we need to determine how long the shutter should be kept open to capture them. Remember if you want to give shape and form to the image you'll need to work out a shutter speed that doesn't allow all the light trails to bleed out of the edge of the frame. To capture multiple explosions the shutter needs to remain open much longer, but as fireworks burn out to nothing and the background is essentially very dark this can be achieved. Where you have an illuminated building or city skyline in the frame then this is much harder to balance. If you look at shots like these you'll see that the sky tends to be much lighter simply because the shutter speed needed to capture multiple fireworks is long and there is much more ambient light.

Light can also be painted into a composition. In much the same way we use a reflector to add light to part or all of the frame, we can also use a light source, such as a torch, to paint in areas of a dark scene. This requires a long exposure so that while the shutter is open, light can be directed at the parts of the scene which you want to brighten and give more prominence. With an artistic eye some striking effects can be achieved.

In all these examples we've looked at moving lights with the camera fixed. What happens if we move the camera, either with fixed or moving lights? The answer is that we exert varying degrees of control over the movement and can effectively paint with the light, creating lines and shapes.

These techniques, as with everything in photography, require you to understand light and how it can be manipulated using shutter speed and aperture. Even though you are 'playing' with light, to make images like these work you will still need to use all your compositional skills to optimize the arrangement of elements within the frame and create impact. Although this type of photography may seem a little haphazard it is based on practical composition but with a splash of individuality and creativity.

Some movement effects can be created by moving the camera even when the subject is essentially static or only moving very slowly. Using the London Eye again as an example, the image on page 104 was created using a zoom lens and zooming in and out during the exposure. The zooming must be smooth to achieve an even effect. In this image the abstract effect has been achieved by rotating the camera during the exposure.

Low Light and Noise

Anyone who was involved in photography in the period BC – before computers – will be familiar with the acronym ISO. The letters stand for International Standards Organization – the world body governing all international standards – and refer, in this case, to a standard measurement of the sensitivity to light of photographic film. For example, Fuji Film market two Provia films, one rated at ISO 100 and another at ISO 400, the latter being 4 times as sensitive to light as the former.

In digital photography the same acronym and numbering system (ISO 100, ISO 200, ISO 400, etc.) is used in relation to the photo sensor. However, unlike film, here ISO relates to amplification rather than sensitivity. For example, when set to ISO 400 the light signals that are detected by the sensor are amplified twice as much as when the ISO is set to 200. In relation to exposure, the result is the same: increasing the ISO rating enables shooting at faster shutter speeds or smaller f/numbers – or both.

In a nutshell, sensitivity (film) and amplification (digital) is the difference between the two media in relation to light. Film is made more or less sensitive depending on the size of the silver halide crystals used in its manufacture, whereas the common sizes of the photo detectors in a digital sensor remain fixed but the light signal is increased (amplified) with each upward increment in ISO rating. Fortunately for photographers, and to make life easy, the terms have been kept consistent to the extent that they are, to all intents and purposes, interchangeable.

Why bother with ISO?

The question here, of course, is why should you bother with ISO – why not let the camera worry about it while you get on with taking pictures? The answer lies in image quality. Film is susceptible to graininess – a result of the crystals used in their manufacture. The larger the crystals, the grainier will be the image, and the higher the ISO, the larger the crystals. Although grain can be used for artistic effect, particularly in black and white photography, largely it is considered a sign of poor image quality. As such, most professional photographers shooting color film have a preference for low-rated ISO films, such as Fuji Velvia (ISO 50) and Kodachrome 64 (ISO 64).

Digital images don't suffer from grain. Since there is no use of silver halide crystals in a digital sensor there simply is no grain. However, another image-degrading phenomenon occurs – digital noise.

There are two aspects of the photographic process that create noise. One is the heat generated by the sensor during long exposures (typically greater than 1 second) and the other, amplification, relates to ISO ratings. As you increase amplification of the light signal so you increase the likely occurrence of noise, which appears on an image as random and unrelated pixels, often of bright colors (e.g. pink, green, red and magenta).

Noise is more prevalent in shadow areas, due to the manner in which photo sensors work. Digital sensors are simply photon counters and variances in tone is managed by a halving or

Digital noise occurs when a long exposure is used. This can be seen in this image and is most visible in the darker areas as red, green and blue dots.

doubling of the number of photons in a photosite for every full stop difference in brightness. That is to say, the brightest pixels hold the most photons, the next brightest half as many and so on down. As such, by the time you get to the darkest pixels very few photons exist, allowing noise to show through and, to some extent, overwhelm.

As noise is considered (generally) to be image degrading, image quality can be managed, in part, by controlling the ISO setting – the lower the ISO rating, the less of a problem noise is likely to be. In this way, the relationship between digital image quality and ISO (amplification) rating mirrors that of film image quality and ISO (sensitivity) rating. In practice most DSLR cameras, particularly more recent models, are not susceptible to amplification noise at ISO ratings lower than 400. Above ISO 400, however, and noise can become problematic.

Pro Tip: Dealing with in-camera noise

If you are working with a high ISO rating (ISO 400 and above) use the noise reduction (NR) function in the camera menu options to reduce the level of visible noise post computer processing. Some cameras have a single setting for noise reduction. Others such as my Nikon D2X have individual settings for high ISO noise reduction and long exposure noise reduction.

CCD Versus CMOS Sensors

On the whole, DLSR cameras use either a CCD- or CMOS-type sensor, the latter more typically in professional specification DSLRs, such as the Nikon D2XS and Canon 1DS mark II. Due to the nature of CMOS sensors they are more susceptible to noise than CCD-type sensors. In a recent experiment, shooting a night scene using both Nikon D2X (CMOS-type sensor) and D200 (CCD-type sensor) cameras and a constant exposure, the image taken with the D2X shows a significant amount of noise across the whole image, whereas the image taken with the D200 shows very little noise, even in the shadow areas. Whatever camera you use you should do some test shots to determine when noise becomes a problem and how best to minimize it.

Flexibility

One of the advantages of the ISO setting on a DSLR camera is the fact that ISO can now be changed for each individual shot. With film this was only possible when using sheet film with large format cameras. Otherwise, once the ISO had been set for a particular roll of film we were pretty much stuck with that rating unless or until the film was changed.

The ability to set ISO independently for each frame brings greater flexibility when setting exposures. For example, say you were using Fuji Velvia ISO 100 to photograph a landscape scene that required maximum depth of field (a small aperture) but available light was so low as to cause too slow a shutter speed to enable hand holding the camera. With film there was little you

could do to change either aperture or shutter speed without compromising depth of field (aperture) or, in this example, camera shake (shutter speed).

However, with a DSLR you now have a third option – to adjust the ISO rating for that particular shot. Using the above example, the existing shutter speed and aperture can be maintained and ISO increased to enable an accurate exposure at the preferred exposure settings (or, of course, you could simply use a tripod!)

A Balancing Act

In the field, of course, it will always be a balancing act between shutter speed, aperture and image quality. Ideally every shot would be taken at ISO 100 and noise caused by amplification would cease to be a problem. However, that's an ideal world and the reason there are optional ISO ratings on our cameras is that we don't live or photograph in ideal conditions all of the time.

While working on a project photographing the landscape under moonlight using a Nikon DSLR, it was necessary to experiment with managing the most appropriate balance between long exposures and ISO to keep both heat-generated and amplification noise to within a commercially acceptable level.

In reality we all have to work with these kinds of limitations and use the camera's functions to produce the best quality result possible given the conditions under which we're working. From a professional perspective here's our advice: keep ISO at 200 or below whenever possible, stretching it to 400 when absolutely necessary.

Practical Composition

Photography is a form of communication and just like any other type of communication a photograph works best when the message it reveals is relevant, meaningful and unambiguous. For example, if we were to start writing now about a child's model railway, which is upstairs in our loft and has a model Thomas the Tank Engine with his two carriages, Annie and Clarabelle; as well as James, the shiny red engine, and Thomas's friend Toby …

ISO 200

ISO 400

ISO 800

ISO 1600

you'd probably quickly switch off and go read another book. Why? Because the message we're relaying isn't relevant to the reason you're reading this book.

Similarly, if we were to write all my practical advice along the following lines: 'You can overcome the failings of the TTL meter by telling the camera to alter the exposure', you would be forgiven for asking some or all of the following questions, "What do you mean by the word 'failings'? What does 'TTL' mean? How do I 'tell' the camera to alter exposure? How much should exposure be altered by?". Again, fairly quickly you'd switch off.

Composition is the art of making a photographic image relevant, meaningful and unambiguous. Practically, there are compositional guidelines to help you construct an image. Some of these guidelines are very familiar, such as the rule of thirds, some less so. In all cases, they are simply guides and, although they are useful whilst you're developing your compositional skills, adhering to them rigidly will ultimately only stifle your photography. Perhaps the most important thing to remember is that for every action you take with the camera – changing exposure settings, switching lenses, moving the camera position, altering camera angle, etc. – there is a visual reaction which changes the compositional properties. If you understand how each of the possible changes you can make will affect how the image is reproduced in photographic print, you are in complete control of the picture making process – which is where you want to be.

To illustrate this point some of the classic compositional guidelines are outlined below and we have added an explanation of the consequences of using or ignoring them.

The first and possibly most well-known compositional guideline is the rule of thirds. Here an image is divided into equal thirds both horizontally and vertically. The theory states that aligning a photograph so that the principle subject is positioned at one of four imaginary intersections, particularly the point one third of the way into and across the image space, creates more tension, energy and interest than if the subject is positioned centrally – and it's true, it does. However, the rule of thirds also does something else. It opens up the picture space and helps

Practical composition is about creating clarity in your images so that the main subject has impact. In this shot would it be better if the out of focus signal in the foreground was excluded from the frame? These are the type of decisions which you must make with your own compositions.

to emphasize not just the main subject but also surrounding objects and detail. This is one reason it is popular in landscape photography, where often the photographer wants the viewer to engage with the whole of the picture space.

What happens, however, if your aim is to isolate the principle subject from the background? In this instance the rule of thirds works to the photographer's disadvantage, precisely because it opens up the background space. To isolate a subject within the frame, positioning the subject centrally will create a far better composition, not necessarily lacking in tension, energy or interest.

Another compositional 'rule' states that once you have determined the main subject, fill the frame with it, get as much detail as you can. Again, it is important to understand

It is common for subjects to be placed centrally in the frame, usually out of laziness because this is where the main focusing point is usually positioned. However central compositions often lack impact. In this portrait, placing the boy centrally doesn't work because he is looking to the left and the viewer is immediately taken out of the frame to where he's looking. In the second shot, the subject is placed off-centre. Now the boy looks in an empty space. This space makes his expression seem much more thoughtful but also allows the viewer to come back to the subject and now you can see the hands which, in turn, point you back up to the boys face. Space is a valuable and often under-used compositional tool.

the effects of following the rule. When a subject fills the frame it is emphasized and isolated from the background. The image becomes all about the subject and nothing else. Reducing the size of the subject to include a larger portion of peripheral information changes the message the photograph relates and you are no longer confined to simple portrait or record shots.

With wildlife and people photography, in particular, another guideline asserts that a living subject should always be photographed at eye level, which makes the image more engaging. This assertion is based on psychology and relates to theory that is referred to as the parent/child relationship: parents look down at children and have control over them, whereas children look up at parents and are subordinate to them. This relationship is transferred to a photograph when a person or animal is photographed from significantly above or below eye level.

The theory goes on to say that when we communicate at eye level (adult to adult) the relationship changes to one of equal status. Neither party is submissive to the other, making the photograph more engaging. However, there are times when abandoning the rule works equally as well, such as when the aim of the picture is to instill a sense of power or evoke a feeling of inferiority.

Here's another example. Since in the western world we read from left to right there is a school of though that suggests we should design photographs with the same direction of flow. In doing so the eye follows an inherent, natural course through the picture space. However, by reversing the flow, particularly when a subject is placed at the edge of the frame, the eye can be led back into the picture space, rather than being allowed to exit it.

This last example has more to do with attitude than any specific rule but is perhaps the most important. Often there are times when weather and lighting conditions are less than ideal for photography. We believe, however, there is no such thing as bad weather or bad light. Every situation will lead to arresting images if photographed with a positive attitude. Our approach on these less than ideal days is not how are we going to keep dry or warm or from being swept of this cliff by the wind, instead ask ourselves how can we use these conditions to our advantage. Photographically, all conditions are ideal, just maybe not in the way you'd originally imagined.

However, before you rush out with renewed vigor there are some further considerations to take into account. The first and by far the most important step in practical composition is to define your subject – decide exactly what it is you are taking a picture of.

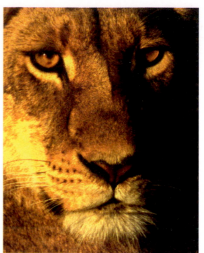

Whether photographing people or animals, the eyes are our first point of communication and engagement. As a result they can be very powerful within a composition and when looking directly at the camera they have their greatest power. In the first shot (top left) the portrait of the lioness is engaging but look how much more intense her expression is, and particularly the eyes, when cropped tightly into the face. The same intensity is also evident in the shot of the woman.

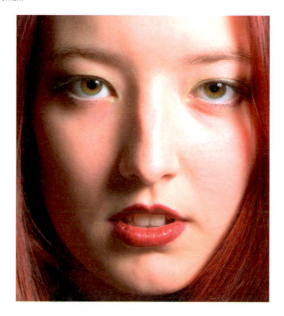

Defining Your Subject

If we were to ask you to draw a picture, your immediate response would probably be to ask, 'What of?'. It's a reasonable question. Why, then, do so many photographers head out with their cameras without asking themselves the same question? Undoubtedly there is a certain buzz of anticipation when you simply head out with a camera with no fixed goal in mind. However, commercially, to approach photography in such a carefree way would likely result in economic failure. From a non-professional viewpoint, it also means you are less likely to return home with that compelling image.

The reason for defining what it is you want to photograph before you pick up your camera is based on the theory that it's a lot easier to find something when you know what it is you're looking for. Otherwise, photography is a little bit like looking for a specific piece of a jigsaw without knowing what the completed puzzle looks like.

When beginning an assignment we head out with a clear idea in our heads of what it is we want to photograph. Again, this doesn't mean the mind is closed to ideas and opportunities that present themselves on spec, it simply means that we head out with a plan. This plan may be very specific, such as the time when writing a book about wolves that needed various illustrative shots of wolf behavior. In this instance, a list of all the images needed to go with the text was written first before setting out in order to capture them.

Other times, the plan may be less prescriptive. For example, at one time, we were particularly intrigued by zebra camouflage and how it worked, since a black and white striped animal living in a yellow savannah doesn't on the face of it seem to make much sense. When we learned that it is all to do with how lions see the world we set out to photograph zebras not as we see them but as lions do. In this case, the subject of our image was defined as camouflage and we composed the photograph in such a way as to show the workings of zebra camouflage.

When you think about it, this is the only way to approach photography. For example, how do you know what lens aperture

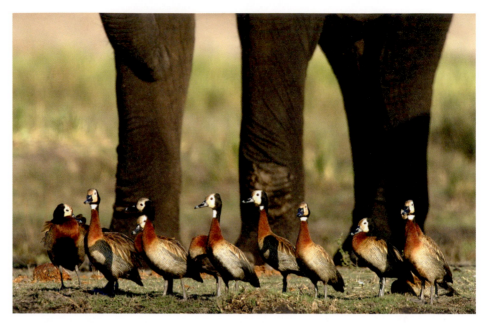

By cropping the elephant at the top of the legs, emphasis is given to the great difference in size of these two wildlife subjects.

This image has been composed to emphasize the density of herds of migrating wildebeast.

or shutter speed to set unless you know exactly what it is you are trying to achieve visually?

Another aspect to photography is imagination and, when defining your subject, you should try and think laterally, away from simplistic literal interpretations of the subject. For example, an easy approach to wildlife photography would be to head down to a local safari park or zoo with the intention of photographing elephants. However, an image that is simply captioned 'An elephant' is likely to be uninspiring and reveal nothing new about the subject that we don't already know, nor elicit any form of emotional response.

When thinking about how to photograph a particular subject, it helps to think laterally and away from a literal interpretation of the subject, unless, of course, that specifically is what is called for. When approaching a wildlife subject we tend to think in terms of expressive or descriptive words, such as power, movement, perspective, speed, togetherness, bonding. These words then define the subject and affect how we approach the image making process. For example, if we are trying to express a sense of motion or speed we will set a slow shutter speed to blur the movement of my subject.

Approaching photography in this way makes choosing between shutter speeds or apertures or lens focal length easier and more effective, which in turn will increase your ratio of 'keepers' to 'throwaways'.

Getting Your Message Across

The reason most photographs fail is that they include too much erroneous and distracting information in the picture space. As we described earlier, photography is a form of communication and a photograph is most effective when the only visual information it contains relates directly to the message the photographer is trying to convey. For example, if the subject of an image is pattern, then the only thing in the photograph should be pattern. Including anything else will simply dilute your message.

All of the tools you need to remove visual information from the image space are right there in your hands. They are the controls

in your camera. The physical and technical aspects of these controls are not the subjects of this book. Here, we want to explain how to use them creatively.

In-Camera Cropping

The most obvious method of removing visual information from the image space is to physically crop it, by picking up your tripod and moving it closer to the subject (or moving your legs, if you're handholding the camera). We emphasize this method over simply staying put and using longer focal lengths to narrow the angle of view for the reason outlined earlier (see Lenses and Perspective, pages 78–84).

By tightening the crop, the image on page 117 emphasizes the behavior displayed by this elephant for more than this image.

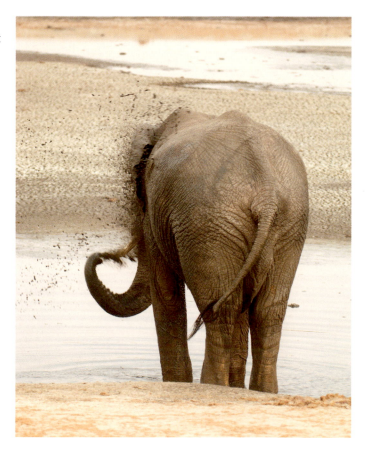

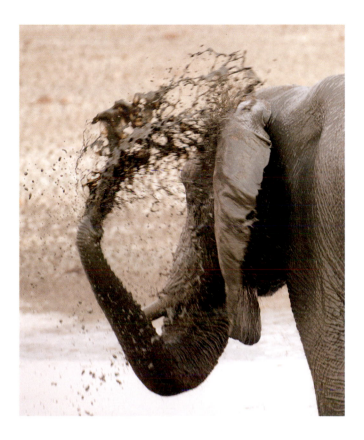

Of course, using a longer focal length lens to reduce the angle of view, thereby cropping peripheral detail from around the main subject, is a legitimate tool at your disposal and, where the impact on the relationships between two or more objects on varying planes is negligible or unimportant, it is an entirely appropriate method to use.

Focus and Depth of Field

When it's not feasible to crop the image any further then a different approach to removing pictorial detail must be taken. One such option, described in detail in the Focus, Aperture and Depth of Field section (page 84), is to blur it, using sharpness (focus) and apparent sharpness (depth of field) to emphasize and give order to objects in the picture space.

Lighting the owl separately and under exposing the background removes some of the distracting detail behind the owl, helping to isolate (and therefore emphasize) it in the image space.

Lost in Light

The third tool at your disposal for removing detail from a scene is exposure. When we think of exposure, typically we think in terms of revealing detail across the full tonal range. However, from a contrary perspective exposure can be used to hide unwanted detail. For example, shadow areas can be underexposed to make them detail-less black, whereas light tones can be overexposed to render them featureless white.

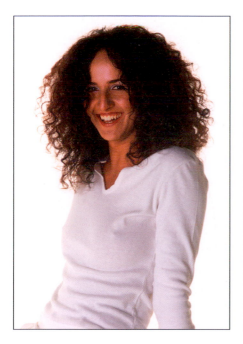

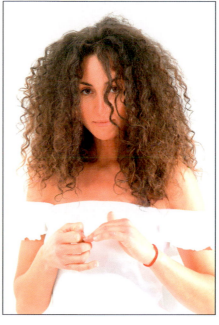

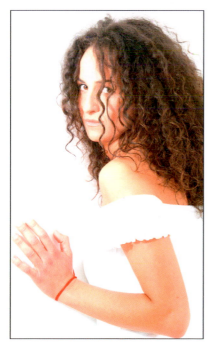

Exposure is also an important compositional tool. In the first shot (top left) the skin tones are lit and exposed normally so the woman's white top is visible against the white background. In the other two shots varying degrees of high key lighting have been used to remove detail. The same effect can also be achieved by over-exposure. In the second shot skin tones are still visible on the face and shoulders but detail in the white top is bleached out and the outline lost against the background. In the final shot the skin tone also starts to bleach out. This technique is often used to remove distracting detail and, in portraiture, to remove or reduce lines, wrinkles and skin blemishes.

For instance, an obvious example of using underexposure to remove visual detail is the silhouette. In a silhouette, shadow detail is underexposed to remove the design elements, color, pattern and texture. In so doing, shape becomes the predominant compositional feature.

Another example of using underexposure to remove unwanted detail is found in close-up photography. By exploiting light fall-off from a macro-flash (as light travels further from a flash unit it diminishes in strength, so foreground objects receive more light than background objects) and exposing for the foreground the under-lit background, which would need a longer exposure, is underexposed and rendered featureless black.

Mind Games

Something else to consider in photography is that composition is all about psychology, and it is perfectly feasible for you to alter the way someone feels simply via your choice and placement of visual elements. For example, take one of the most commonly used of these elements – the horizon line.

Placing the subject in the centre of the frame isolates it from and de-emphasizes the background.

It is a commonly held view that a horizon should never be sloping, with good reason. The horizon is our natural form of orientation. When we're lost our first instinct is to seek out the horizon because it gives us a visual point of reference. Indeed, when no horizon is visible disorientation quickly follows. My father used to be a pilot in the RAF – towards the end of his flying career he was an instructor and the number of occasions he would tell of inexperienced pilots trying to land their multi-million pound aircraft upside down after long periods without sight of the horizon was frightening.

Since it is our natural form of orientation, the horizon creates in us a feeling of calm, inner peace and composure. When we see it level in a photograph it evokes the same emotions. In some genres of photography, such as landscapes, this is typically

The only difference between these two images is a slight twist (about 30-degrees) in camera position. But the sloping horizon in the image on the right creates a sense of motion and energy not apparent in the image on the left.

a good thing, as landscape images tend towards harmony, tranquility and serenity.

However, what if your aim is not peace and tranquility? A sloping horizon puts us off balance because in nature the horizon is never sloping. To see it angled upsets our sense of wellness. If your aim is to create a feeling of friction and imbalance then it is entirely appropriate to slope the horizon.

As an example, consider the two images taken from an aircraft cockpit (page 121). The first image, where the horizon is level, gives an impression of a slow, romantic jaunt in an aircraft from a bygone era. The following image, however, creates a strong sense of motion and energy – it is far more dynamic. All that has changed physically is a slight turn in the orientation of the camera. However, the emotional difference between the first image and the second is stark.

Color is another visual element that can affect our emotions and physicality. Some time ago, a group of psychologists ran a test using racehorses, to see how our bodies reacted to different colors. Immediately after a close run race, they took the winning horse and put it in a stable painted blue. They also took the horse that came in second and put it in a stable painted red. The exercise was to see whether color would affect the speed at which the horses' bodies cooled – and it did. The results showed that the horse in the blue stable – blue being a cold color – cooled down far quicker than did the horse in the stable painted red – red being a warm color.

As well as the effects of color on our physicality, color also affects us emotionally. For example, bright harmonious colors (e.g. yellow) suggest energy, joy and happiness, whereas jarring colors, like crimson red, may evoke a sense of danger, anxiety or alarm.

The benefit in understanding the psychological affects of line and color and other visual components on humans is that through thoughtful and purposeful composition, a photographer can literally alter the mood of the person viewing the image. It is an intriguing concept and a powerful tool in capturing compelling images.

The Defining Moment

A question we are often asked is, 'How do I know when is the right time to press the shutter?'. It's a good question and perhaps the hardest to answer because, if you have read the preceding sections, you will by now know that in truth it will depend on how you have interpreted the scene. However, over the years we have come up with a technique that often works and involves asking yourself two questions.

In photography, the moment when the shutter is released can make or break an image. So as photographers we are always looking for the defining moment, and this moment depends on what we want convey in an image. In the first shot (top left) the groom is looking away from his bride and all intimacy is lost. The shot of the kiss conveys a very different message and captures a private moment. The last two images capture joy and laughter. Where the couple are facing each other, this moment is between them but when the bride turns her head towards the camera the viewer is invited to share the moment.

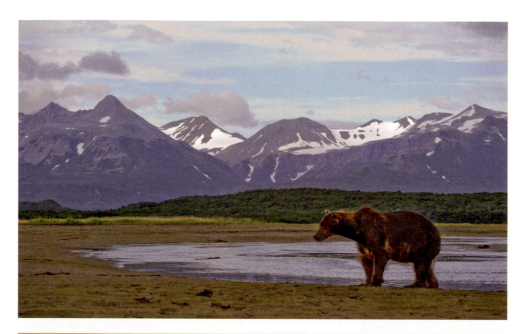

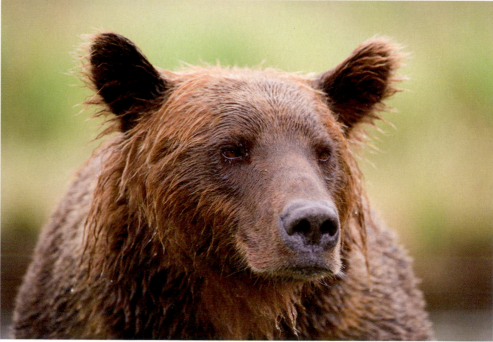

Compare these four images and write your own captions. You will notice that the stronger the image the easier it is to caption.

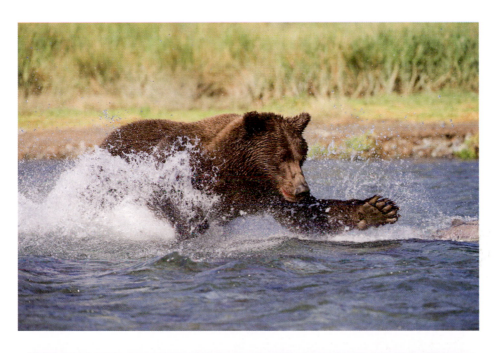

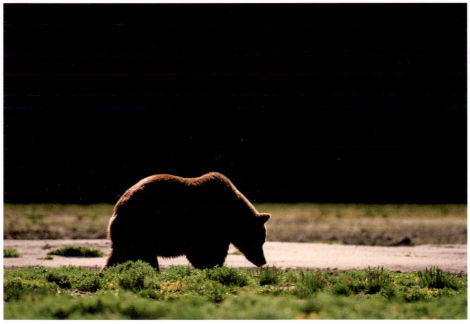

The first question is, 'How will I caption this image?'. Essentially what you're asking is, 'When I get back to the studio to edit and process this image, what caption will I enter into the EXIF data?'. If the only answer you can conjure is the name of the place or species, don't waste your time making the photograph. This is a record shot and there are more than enough of those in the world already. For example, imagine a picture of a bird perched on a tree with its beak closed. The caption would read 'A bird'. Now imagine a second image of the same bird taken a moment later, this time with its beak open. Now the caption would read 'A bird singing'. The simple addition of a noun changes the meaningfulness of the caption and, by default, the power of the photograph.

Once you've taken the first image, the second question to ask yourself is, 'How can I photograph this scene differently?'. We often practice this aspect of the technique when leading a group of photographers. By watching what each photographer is doing, we can fairly easily gauge the image they are making. This leads to the question, 'How would I do it differently from this person?'. Indeed, on most of our longer photo safaris, we typically spend at least one day where we photograph alongside the group and then show the results on-screen at the end of the day, comparing how we visualized the scenes we encountered with how others saw them. This is done to boost our egos, simply to reveal how the same subjects can be interpreted very differently through different individuals' eyes.

Developing a Personal Style

When we were learning about photography, personal style was something that photographers talked about but never explained. Consequently, it was some time before we began to appreciate what they meant, longer still to develop one of my own. Personal style is something you are possibly aware of, without necessarily recognizing it for what it is. For example, it's reasonable to imagine more people than not could relatively easily identify a painting by Monet or Dali, or an Ansel Adams landscape photograph. This is because these artists have a personal style that is both recognizable and identifiable.

A photographer's development tends to run in a cycle. We start out with simple studies or portraits, before moving on to more dynamic compositions, followed by creating a sense of environment or place, ending finally with artistic interpretation. Having spoken to several fellow professional photographers working in different areas of photography, all identify with this cycle. Somewhere through the cycle a pattern emerges that reveals for an individual photographer a preference for a particular technique or style of photography.

A personal photographic style tends to originate from our own visual values and from the way we tend to see the world around us. For example, Chris Weston's is wildlife photography. Chris thinks of wildlife as being dynamic, always moving; and he likes to capture this sense of movement by using slow shutter speeds to create motion blur. Over time, this type of image has become synonymous with Chris's work – a personal style.

There is no easy way to teach personal style but making you aware of the idea of it should set you on the road to at least thinking about your own values and preferences. Once you have identified these within your own mind, developing a personal style of your own is a matter of following your own beliefs.

The Process of Image Capture

Understanding the Photographic Process

As photographers, we used to rely on a photo lab to develop, process and print our images, with only a little guidance from ourselves. The digital revolution and the simultaneous expansion of affordable computing power have brought the photographic lab to our desktop without the need for a darkened, light-tight room. Now photographers have the power, at their finger tips, to optimize their imagery or transform it in highly creative ways.

With this power, though, comes the requirement to understand the equipment, software and digital imaging techniques, to a degree that wasn't previously essential. Photographers now need to have the skills that used to belong to highly trained and often very experienced lab technicians and printers.

When you first sit down at your computer and view your images on the desktop, it's all very exciting and the accessibility makes it look easy. In reality, how easy it is depends largely on how well you've taken each photograph in the first place. Overlooking the fact that photography is about images and taking the 'I'll fix it later in Photoshop' approach simply stores up problems which will ultimately confront and confound you. As with all things photographic, there are many ways to do something but there is also best practice which will make the process, from image creation through to output, so much more efficient, rewarding and pleasurable.

This process starts before you press the shutter. First, the camera must be set up properly. An understanding of the basics of how to control light and modify an image simply through selection of aperture and shutter speed is obviously essential, but familiarity with your camera's menu and selection of the best options is also important.

The menus on many DSLRs are overly complex and confusing, with the vast majority of options of little or no use. Photography is simple and fun, yet an overemphasis on extra features, rather than ensuring the essential features are present, can seriously hinder a DSLR user's development as a photographer. Couple this with terminology borrowed from the computer industry and image-editing software often originated with graphic designers in mind, and it is little wonder that many DSLR users find the whole process daunting.

To unravel this complexity let's start by looking at the cameras themselves, then work through the handling of the images in a computer to achieve the best results.

Advantages and Limitations of Digital Cameras

Digital cameras are a fantastic invention that have revolutionized photography. However, their evolution has been incredibly rapid. The digital camera is essentially the same light-tight box which cameras, in all their various forms, have essentially always been. The difference though, and it's a very important one, is that these

Once an image is imported into digital imaging
software it can be manipulated in a myriad of
different ways and photography crosses over into the
art of digital imaging.

The first image (top) shows the photograph as
shot. In the second image a cut out of the woman
is simply placed on a different color background.
The third image takes digital imaging towards its
extremes using 3D image rendering software to place
the cut out into an artifical water scene and create a
reflection.

light-tight boxes incorporate an increasingly powerful computer on board. This has led to a number of inherent problems with the technology, not least that much of their development has been led by computer engineers and software developes, rather than more optically orientated engineering.

The biggest concern for most photographers trying to get to grips with digital photography is the overemphasis on complex menus and onboard computer-based solutions, often at the expense of essential optical and mechanical features that are highly relevant to the photographic process and control of the image. Many of the issues have yet to be resolved but there is an increasing awareness amongst the manufacturers that more pixels is not the only, or even the most important, issue facing digital photographers. As a result they are now starting to redress the omission of some fundamentally important features that are essential to the creative photographic process.

There are two key considerations for the DSLR user, dependent on whether you already own a DSLR or about to purchase one. For those who have already started to use one, you probably either are already aware that certain functionality is missing or are wondering why you cannot take your photography beyond a certain level. For you the options, if key functionality is missing from your camera, are unfortunately either to live with what you have or upgrade to a newer model that has this functionality. For those of you that are about to buy your first DSLR then you will be able to make an informed choice based on where you want your photography to go.

Camera Functions

If we take a camera back to its very simplest, it is nothing more than a black box which controls the amount of light reaching a photo-sensitive recording device – silver halide-coated paper, film or now in the DSLR, a sensor. This control is achieved by first setting the sensitivity – the ISO. Once set, this becomes a constant, leaving only aperture and shutter speed to control the image. With these two variables, exposure, movement and depth of field can all be controlled and used as creative tools in the image making process.

It is therefore mystifying why so many DSLRs no longer have a depth of field preview button, especially as SLRs create a bright viewfinder image to aid composition by holding the lens aperture at its maximum, regardless of the aperture selected, until the shutter release is pressed. The result is that composition takes place with a bright image but, unless shot at maximum aperture, the resultant image will have a different depth of field to the viewfinder image, fundamentally changing it and overlooking a key aspect of composition. Of course, with experience, a photographer learns how aperture changes an image but the double check, and essential tool for those difficult shots where precision is vital, was always the accurate view afforded by the depth of field preview facility.

To compound this problem manufacturers have also removed the hyperfocal distance indicators, which provide a guide to depth of field at different apertures, from the barrels of most lenses. This leaves the less-experienced photographer floundering when trying to learn image control through the use of aperture. We have already discussed the importance of aperture control and with it depth of field. Hyperfocal distance marks make photography much easier, but depth of field preview is an essential function on any camera.

Another option that allows creative flexibility relates to another key compositional tool – shutter speed. As we've already discussed, fast shutters speed freeze motion, revealing detail and form, whereas slow shutter speeds allow the photographer to blur motion, creating dynamism and atmosphere while disguising unsightly distractions in a composition. At fast shutter speeds DSLRs offer all the options needed; however, where motion blur is desirable in bright light conditions, many DSLRs don't have enough flexibility at the bottom end of the ISO range. The lowest ISO on many cameras is 100. This is hopelessly inadequate in bright like and often necessitates the use of neutral density filters to achieve even a small amount of motion blur.

It's important to realize that most camera manufacturers produce two ranges of cameras – those aimed at the consumer end of the market, and those which offer more of the functionality and build quality required for use by professional photographers. The same is true for lenses. Differentiating the two ranges is easy as they

will carry different model numbers and the higher quality models will carry a significantly higher price tag. With both cameras and lenses choose the one which offers the features you need at the price you can afford but be aware that you get what you pay for. It's always a good idea to handle a camera before you buy it, check for features like depth of field preview button and lowest ISO, and never forget that a high-quality lens is essential if you want a high-quality image. There is no point in spending a fortune on a camera body if you then put a low-quality lens, or filter, between what you're photographing and the camera sensor.

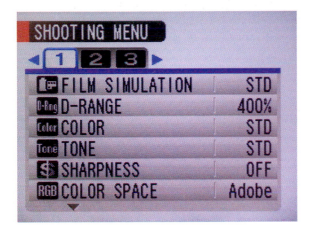

Overly-complex DSLR menus often bewilder photographers with a mixture of computer speak and analogies to film cameras. It's important to get to know the menu on your camera, how to navigate it and which functions are important to your photography.

Chips, Sensors and CCDs

The DSLR is essentially a computer with a light-sensitive chip and a lens. Image capture therefore becomes an electrical process rather than a chemical one. There are two different types of sensor commonly used in digital cameras – CCD (charged-coupled device) and CMOS (complementary metal-oxide semiconductor). Each type has its strengths and weaknesses.

CCDs were used in the early digital camera and have traditionally been associated with higher image quality, but also tend to be more expensive to produce and more power hungry. CMOS sensors tend to be physically bigger with an architecture that is cheaper to produce and which gives greater sensitivity to light. Both technologies are evolving rapidly, though, and both are now used in high-end digital cameras so it's oversimplistic to define differences in such basic terms.

Sensors are made up of a series of photo-sensitive cells, or pixels, which produce an electrical charge in response to light stimulation. The maximum image resolution which any sensor, and therefore camera, is capable of resolving is determined by the number of pixels in that sensor. Quite simply, megapixels (million pixels) is measured as the number of pixels horizontally multiplied by the number vertically, giving the overall number of pixels on the sensor.

In the early and cheaper DSLRs, the sensor is smaller than an equivalent piece of film. This creates a physical problem in that the image has to be focused down onto a smaller area. The effect is to alter the focal length of any lens. These sensors are approximately two-thirds of the size of a frame of film, effectively increasing the focal length by a factor of 1.5 or 1.6. A standard 50 mm lens on a film camera therefore becomes a short telephoto 70–80 mm lens on a DSLR. It is for this reason that it's harder to achieve true wide angle on a DSLR and why lenses with a focal length of 8 or 10 mm are available for digital cameras. On a film camera this would be an ultra extreme wide-angle (fish-eye) lens!

The more expensive pro DSLRs boast a physically larger full-frame sensor, giving true equivalence with the size of a 35 mm film frame and with it no alteration of lens focal length. The higher cost of manufacture means that cameras with these sensors are more expensive, although in due course it is likely all DSLRs will offer these larger chips.

With much of the development focus on megapixels and digital image resolution, especially in the early days of digital photography, it's easy to forget the other key elements of an image, in particular, tonal range, dynamic range and color rendition. Tonal and dynamic range are often confused but are not directly linked. Tonal range is the number of tones that the sensor is capable of recording, from the lightest to the darkest. Dynamic range is the range covered from the lightest to the darkest tones, which need not necessarily be white and black, respectively.

A narrow tonal range gives bands of different tones, whereas a broad tonal range gives smooth, gradual transitions between different tones, giving the impression of continuous shades of

color. Dynamic range determines the ability of a sensor to record detail in the shadow and highlight areas of an image; the greater the dynamic range, the more detail. A sensor with a narrow tonal range, but broad dynamic range, will record shades from black to white but show them as bands. A sensor with a broad tonal range but narrow dynamic range will record a smooth transition of tones but over a limited range; black to gray, gray to white or just shades of gray.

If you see banding in an image this is a function of restricted tonal range. If you see highlights blown out to white or shadows blocking up to black then this is a function of narrow dynamic range.

Loss of shadow and highlight detail in an image is a common by-product of digital image capture and one that has been largely overlooked in the race for more megapixels. Now that resolution from digital camera sensors is comparable with, or greater than, film, the sensor and digital camera manufacturers are paying more attention to issues such as dynamic and tonal range. To achieve these essential improvements some highly innovative changes to sensor architecture are being developed and introduced.

The red overlay visible in this image identifies areas of blown highlights.

As digital sensor technology matures it is in these areas of tonal and dynamic range, and color rendition, that the biggest advances will be seen. When buying a digital camera it is essential to look at more than image resolution, denoted by the dreaded megapixels, which is all most salesmen think you need to know, and to find out how the camera really handles these other important elements of image capture and ultimately image quality.

Choosing File Formats

Digital files must be created in a file format which is compatible with storing digital pixel data. The four most commonly used formats are JPEG, TIFF, PSD and RAW, although images are often saved but not created in PSD (derivation: Photoshop document), as this is a Photoshop file format. The choice of file format when you shoot is critical, so understanding the different options is important so that you can make the most appropriate choice.

JPEG (derivation: Joint Photographic Experts Group) is a compressed file format designed to allow easy transmission of images over the internet and lower volume storage. A compressed file is simply one that is squeezed into a smaller size. JPEG offers a range of compression to achieve smaller and smaller image file sizes, although at the expense of loss of image quality as compression increases.

To compress an image file you must essentially throw away information about that image, thus reducing its quality. Compression is applied on saving and, once the file has been saved, the discarded information cannot be retrieved. If you are capturing images in JPEG only, then it is really important that the original is kept unedited to preserve original image quality. All digital image manipulation should be performed on a copy, which is saved and resaved as few times as possible. Once you adopt this working practice the benefit of needing less disk space to store and archive rapidly disappears with multiple copies of each image.

The JPEG file format is not the optimal choice for capturing digital images but, when captured simultaneously with an uncompressed format, allows quick and easy image preview

plus sharing of a low-resolution version of an image with little or no digital image manipulation on the computer. Any image captured in another file format can also be saved as a JPEG at a later stage if a lower resolution image is needed for internet use or transmission, for example.

TIFF (derivation: tagged image file format) is a universal format for image files, and is widely used as the format of choice in printing and publishing. Although uncompressed, it can also support compression without loss of image data. It was the preferred format for high-resolution capture of images by digital cameras but has now largely been superseded by the RAW file format.

PSD is an Adobe Photoshop data file that offers similar properties to the TIFF file format but with added image handling capabilities, especially with layers and layer masking, in Photoshop software.

RAW, unlike the other file format names, is not derived from some obscure abbreviation but is exactly what it suggests, raw image data captured as recorded by the camera sensor. All digitally captured images require a degree of processing as a function of the way light is transformed into a digital electrical signal. A large part of the cost of a DSLR results from the complex image processing hardware and software on board the camera. The supreme irony of capturing images in the RAW format, now the image format of choice for capturing high-resolution images, is that this on-board technology is largely bypassed to give an unprocessed image.

Capturing an image in an unprocessed state obviously hands control of that image, and with it the creative process, back to the photographer, but with this comes the requirement to then understand how to process that image. It also means that each image must be processed before it can be used. RAW is a file format for image capture only and files, once processed, must be saved in another file format. With images shot in constant light, such as a studio setting, batch processing can be applied to a set of images but in changing light this cannot be accurately done, so processing each image individually on a computer desktop can become very time-consuming.

It is here that the real battle between photography – the making of an image – and digital imaging begins. It is easy to assume that DSLRs have highly sophisticated brains and to abdicate the photography element to the digital imaging stage of the process. In fact, DSLRs have highly sophisticated computer hardware and software. As such they cannot think but can only respond as programmed so that the old adage of 'garbage in, garbage out' applies. In other words, getting it right when making the image is fundamental as the digital imaging element of DSLR photography can only enhance a good image. It cannot rescue a bad one. This is even more fundamental when shooting in RAW because the computer is bypassed in the process.

So why shoot in RAW in the first place? The RAW image format offers flexibility without loss of image data or quality. When taking a digital image, variables such as color profile, white or color balance, levels and image sharpening are applied to that image by your chosen camera settings. These are then fixed as part of the image data. In other file formats these can be changed later, but these changes can affect image quality. With the RAW format, because this is essentially unprocessed image data, the photographer can apply each parameter, giving greater control of the creative process in a way which doesn't compromise image quality. This control extends to adjusting exposure and allowing more information to be pulled from the highlights and shadow areas of an image.

As with all evolving technologies, though, each manufacturer seeks to gain a commercial advantage over its rivals. As a result, different camera manufacturers have differing versions of RAW, many requiring bespoke software to process, at least until image-editing software such as Photoshop and Aperture offer upgrades or revisions to handle these files.

With larger and larger capacity memory cards available, many DSLRs now offer the option to shoot in RAW and JPEG formats simultaneously. This effectively gives a high-resolution unprocessed RAW image and a smaller file size JPEG preview image (either high, medium or low resolution). Older cameras may also offer the TIFF format; however, TIFF files tend to be larger than RAW because data such as color profile is already attached to the file.

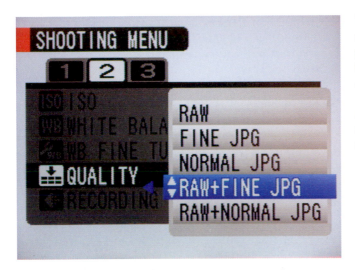

Take some time to set up your camera before you start shooting. Choosing the correct file format is essential if you want to achieve the highest quality. The RAW file format is the most flexible but you will have to process each image.

Jpeg gives you the smallest file size and the lowest quality. This is ideal for web use but may not deliver sufficient quality if you want to print your images.

Navigating Camera Menus

It is important to get to know your camera menus and how to navigate them. Digital cameras offer great flexibility in allowing control of factors such as sensitivity (ISO) and color balance (white balance) from frame to frame; however, it's a source of endless frustration to many DSLR photographers that making the simple changes to important parameters like these can be time-consuming, simply because the menu controls are overly complicated. Unfamiliarity can result in missing the good shot in rapidly changing light or with moving subjects.

DSLRs have become almost overburdened with menu features so it is essential that the menu is easily navigable and allows quick control of the most important features. Make this a consideration when buying a new camera. There are certain other elements of the camera that, once set, are changed infrequently and rarely from shot to shot. Image quality is a good example of this. It's worthwhile spending time learning about the options for making customized settings on your camera. These settings allow you to pre-program certain parameters, such as color balance, ISO, file format, etc., for certain shooting conditions. Once set up this can save you valuable time in switching between different set ups.

As with any tool – and your camera, no matter how expensive and sophisticated it is, is just a tool – it is essential to be familiar

with its controls and know how to use it effectively. Always remember, photographers make great images. Good cameras just improve the image quality and sometimes make those images easier to craft.

Choosing Image Resolution and Color Balance

For most photographers the objective is to achieve the highest quality possible, so the camera is set to the highest resolution. When starting out with digital photography, photographers often set their camera to give the most images on their memory

Changing color or white balance can negate color cast, caused by artifical lighting. One of the big advantages of digital cameras is that you can make these changes from frame to frame.

This shot of the London skyline contains a number of different light sources. The first image is shot on the auto white balance setting. In these different types of lighting can be identified e.g. greenish lights are fluorescent, orangey tones tungsten or sodium etc.

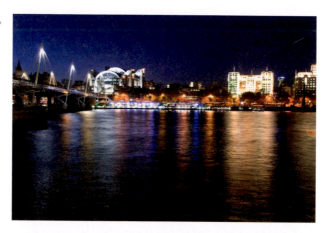

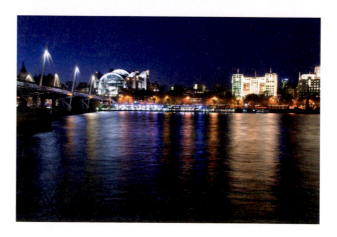

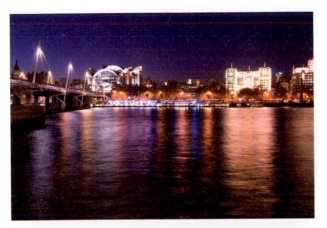

Using the tungsten setting adds a blue color cast (page 144), cancelling out the color cast for tungsten lights. The fluorescent color balance setting adds a magenta hue (top image). There are several different types of fluorescent lighting so some cameras have more than one fluorescent setting.

The middle and bottom image are shot with the sunny and cloudy settings respectively. Both give much warmer images. Note that the cloudy setting gives the more orange image. This is because overcast light is cooler (bluer) than sunlight so color correction adds more warmth.

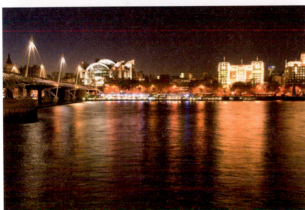

card, when the highest quality image settings, because they are large file sizes, give the least number of images per card. With the option of shooting both RAW and JPEG it is advisable to choose this option and keep your camera on this setting permanently as it gives both high- and low-resolution options.

One of the most usable and underused features on a DSLR is the ability to change the color balance, or white balance, from shot to shot. With film this is only possible from film to film, unless you use filtration, and is not as controllable even then. All light has a color temperature, measured in Kelvin (K).

Color balance can be changed using the white balance listing in the camera menu. A number of preset options can be selected e.g. auto, tungsten, fluorescent, sunny, cloudy, shady, flash.

Some cameras allow color balance to be customized by choosing color temperature in degrees Kelvin (K). Custom settings allow you to fine tune color correction or use a color calibration device.

Think of this as a color hue. Daylight color temperature is fairly constant, except at the extremes of sunset and sunrise, so our brains are able to compensate for any slight shifts which our eyes detect during the day. Camera sensors cannot make these compensations so it is dependent on the photographer do it where required.

Even daylight varies, though, and the light in shadow or on cloudy days is bluer than in bright sunlight. Artificial lighting has much more extreme shifts, with tungsten lighting having an orange color, fluorescent green, neon blue, etc. Newer forms of fluorescent and energy-efficient lighting also have different color temperatures, so photographing in mixed light can become much more complicated.

Changing the color balance assumes that you want to remove the color cast and in many instances this is desirable. However, color balance can also be used as a much less obvious part of the creative process and experimenting with different settings can produce some interesting results. The monochrome gray day can, for example, be a problem when shooting scenic landscapes. Adjusting the color balance can add warm tones or cool tones. Used to the extreme it can dramatically change color, although it obviously applies the same degree of change to all the tones in a scene.

In-Camera Image Processing

As all digital images require some processing it is essential to know what processing is applied by the camera before the image is saved to the memory card. Even when shooting in RAW a small amount of processing may be performed in camera. When shooting in JPEG or TIFF this will be much greater, with some or all of color profile, image parameter, sharpening and adjustment of levels being modified in camera.

Some DSLRs allow you to specify how much modification takes place in camera. With parameters such as sharpening, it is advisable to switch this off or keep it to a minimum in camera, allowing you to make a single adjustment to suit when processing the image in computer for output to print or web.

The image to the left shows the unprocessed RAW image taken from the camera. The image to the right, by comparison, shows the same image as a JPEG file processed in-camera.

Debunking the Myths

With such a fast-evolving technology it is inevitable that folklore and myth develop simultaneously about it. Digital photography is no different but it's important to realize that many of these myths originate, on the positive side, from marketing and sales of new products seeking to gain an advantage over competitors and, on the negative side, from photographers resistant to change for no other reason than that new is different.

As a photographer, whether you are new to digital photography or have been using it from its birth, you should take much of what you hear with a healthy pinch of salt and work out what is fact and what is fiction. With the continued evolution of the DSLR, these differences will converge over time so it's important to understand what affects the image and what is simply window dressing.

A good case in point is the perception that digital photography is cheap. This is derived from the absence of a fixed cost every time you press the shutter. With film cameras this process costs the price of a frame of film and processing but with digital cameras this appears to cost nothing. On its own this is almost true, as the higher battery usage is the only identifiable cost and this is negligible. The real cost of digital photography comes with volume of images shot, and the hardware and software needed to process and store them.

Digital cameras have the built in obsolescence of any fast-developing, new technology, as do the memory cards, computers and hard drives. Couple this with battery use and outlay on memory cards, computer and the several hard drives needed for storage and back-up, then the true cost of digital photography starts to look significantly higher.

On the negative side, the early digital cameras being presented as a solution to all our photographic needs, when clearly their resolution left a lot to be desired, contributed markedly to the perception that digital cameras did not offer enough quality for serious photographers. Certainly now image resolution is comparable to, or greater than, film. However, the camera-buying public has paid a high price in being used as the testing ground for new technology before it was really ready to be

taken seriously. Like mobile phones, there are millions of digital cameras sitting in cupboards and drawers, not being used simply for quality reasons.

The most important thing here with digital photography, in fact with any photography, is not to believe the manufacturer hype but to test out your equipment for yourself, discover its strengths and weaknesses, then use both in creating interesting imagery.

Strengths, Weaknesses and Better Photography

Digital photography has some major strengths. First, the ability to view an image immediately after taking it gives instant gratification. Second, speed is also a factor as it offers a fast way of working so you can shoot more. Third, images are easy to view and store. Fourth, they can be processed and manipulated without the need for a darkroom or any specialist equipment other than a reasonable desktop or laptop computer.

It's important to realize that these major strengths of digital photography are also its major weaknesses.

Arguably the most overused buttons on most DSLRs are the shutter release and delete. Whilst it is 'nice' to be able to view images on the camera LCD display this can have disastrous results if you are tempted to make judgments, based on these previews, about anything other than what's in the frame. Many a sharp focused image has been discarded in camera in favor of a similar, better framed, but out of focus image, simply because it is difficult to judge on a tiny preview. Likewise, judgment of accurate exposure is simply not possible on these LCD screens.

The wise digital photographer makes all these judgments, and edits all images, on the computer desktop not in camera. This also offers the opportunity to learn from the images that didn't work by assessing what went wrong so that the same mistake isn't repeated next time you shoot. Good photography doesn't need an LCD screen. This is a safety net for less-confident photographers but more often than not it relieves them of thinking carefully about what they're doing and leads to sloppy mistakes. There is nothing like not being able to instantly see the results of a once in a lifetime shot to focus the concentration and brain on getting it right!

For the working professional sports or news photographer, speed has become an essential part of the job. However, for most non-professional photographers it is actually the enemy of good creative photography. Photography is about understanding how light interacts with a subject and how this changes with time and viewpoint. For many great shots the photographer is waiting for the light and working with it. Only when photographing fast moving or rapidly changing situations is it essential to have the speed which digital photography offers, and usually this is only important in quickly making the images available to view, not in how you shoot them.

For sports and press photographers, the immediacy of digital photography is a big advantage. Sports photographers can now edit and transmit their images back to the sports desk during the match or event.

Although this shot has captured the moment, the depth of field used is too deep and the action is lost against the crowd.

From the photographer's area behind the goal you can get close to the key action and the low viewpoint adds drama.

Framing and depth of field allow the image to capture both the context of action and the crowd in the stadium.

Shooting too wide loses the impact of the action.

A tighter crop shows the moment much clearer and the shot has more impact.

There is some fabulous digital imaging software available for handling images but these programs should be viewed as tools to help you achieve the image you've already visualized before you pressed the shutter, not as fixes for poor technique. Images can certainly be transformed using digital imaging software, much as they could be in a traditional darkroom, but a good image to start with is an essential part of this process.

With action shots it is easy to place the subject centrally because this is where the camera focuses and you are concentrating on the action. As a general rule action shots are stronger if you allow space for the action to move into, in this case include more on the right of the frame.

At any sporting event the crowd can provide an interesting, sometimes more interesting, alternative to the sporting action itself.

As photographers we should be looking to craft each image rather than take it because it's there. The latter approach leads to huge quantities of average or poor images, a considerable amount of image editing, and time spent in front of a computer, to find and process the few good ones. A 'shoot less, shoot better' approach to digital photography will lead to better images, lower volumes of digital files, less storage space

The area inside the triangle is a two-dimensional interpretation of the color and tones recordable when shooting in Adobe RGB

The color space recordable when shooting in sRGB is smaller and some color clipping occurs, particularly in the green and blue tones.

on computers and hard drives, a more manageable image collection, less time spent in front of a computer, and more time to spend making more good images. Break this vicious circle and your photography will not only improve but will become more enjoyable.

Color Space and Color Interpretation

There are many aspects to color and its management that most photographers weren't even aware of until they were confronted with making decisions about color in their images.

Color Space

All image files have a color space. This defines the amount and limits of the colors and shades of color that a particular image can hold. This is called the color gamut. The color space of an image is chosen prior to shooting. When you press the shutter it's assigned to the image file and is limited by the largest color space that the sensor is capable of capturing. When shooting in RAW, this assigned color space can be easily changed afterwards but is still limited to the maximum available for that camera's sensor. Different color spaces are capable of capturing differing amounts of color information so choosing a smaller color space means that an image is made up from less colors and shades.

The importance of color space only becomes obvious when you output an image for publication, as a print or on the web. How an image appears depends on the smallest available color space in the process from capture to output. If you shoot an image in the biggest color space available but output it on an inkjet printer with a much smaller maximum color space, then the print will only show the colors and shades within the limits of the printer color space, even though the images hold more information. Print the same image on a printer with the same biggest color space as the image and you will be able to bring out more colors and subtle shades. Similarly, if you capture an image with the camera set up for a small color space then try to output it on a printer with a much larger one, the print will be limited by the color space of the camera.

At present the biggest color space available is Adobe RGB (1998). The RGB stands for red, green, blue – the constituent colors of

light. Some DSLRs will capture images in this color space but many are limited to sRGB, which is a slightly smaller color space and offers a narrower gamut of color. Some inkjet printers are now capable of printing in Adobe RGB but many photo labs print only in sRGB. The internet has a much more limited color space. It is often suggested that you should find out the color space of the output device and shoot to this, but this approach is somewhat short sighted as you can always convert an image to a smaller color space but you can't achieve more than the color space on capture. A better approach is to shoot in the maximum color space available, then you have the flexibility to output an image in many ways and have built in a degree of future proofing to the usability of your images. After all, who is to say that the internet won't have an Adobe RGB color space, and inkjet printers an even greater one, in 10 years time?

It's also worth being aware of Lab Color and ProPhoto RGB. Lab Color is a mathematical color space which defines the absolute limits of color, in terms of human vision, and is always the same in any environment. All other color spaces, such as Adobe RGB and sRGB, fall within the limits of Lab Color. ProPhoto RGB is the exception to this as it is larger than Lab Color. The problem is even if you record information in this color space, you can't edit it accurately and when you view an image on a monitor or output it to print this is done in a smaller color space. Clipping or compression of color then occurs. It is often recommended that photographers use this color space but there is no point in doing so and it simply increases file sizes without a visible benefit at output.

Color Interpretation

The color space sets the limits of achievable colors and shades in an image. Color interpretation is part of the photographer's creative process, and is a function of exposure and color balance (white balance). Metered exposure reproduces color as we see it. However, applying some creativity to exposure can interpret color differently.

Imagine a herd of elephants walking away from the camera and towards the sun. It's late afternoon and the sky has the first tints of yellowish orange before sunset. The exposure which reproduces colors as you see them will show elephants

Software such as Adobe Photoshop provide both short cuts and sophisticated adjustments. These options allow you to make adjustments to exposure and color. This shot shows the image of the moon and sky as captured by the camera.

Using the levels option, the image can be customized precisely.

The auto levels option give a much cruder adjustment. With some images this will give an interesting result but as a general rule these 'auto' options for levels and color balance should be avoided.

in semi-silhouette against a yellowish orange sky. The shot could be OK, but not striking. Now imagine underexposing this same shot by at least one stop. The result is black silhouetted elephants against a dark orange sky. Underexpose more and the silhouettes stay black but the sky goes to red.

This example demonstrates the true craft of photography – not simply to take any scene at face value and to document it, but to visualize an image then use the tools at your disposal to capture your creative vision in an image.

This is perhaps an extreme example of how color can be interpreted in an image because underexposure darkens the whole image, and this one relies on the fact that a silhouette is a silhouette and cannot be darkened. However, subtler changes in exposure can be used to slightly darken or lighten tones to create impact. Underexposure darkens colors, making them more intense. Overexposure lightens them, creating more pastel tones and shades. Add changes in color balance into the mix and you can alter colors by creating or removing color casts across the whole image.

Colors can be altered to extremes but, as with many creative effects, it is often the subtler ones that have the most impact. Experimenting with color is great fun and can produce striking imagery. Photographers using film have been doing this for many years through choice of film, filtration and by adjusting chemical processing. For DSLR users, interpretation of color is more easily accessible and the results can be rapidly reviewed and assessed.

RAW Conversion

Opening a RAW image is like opening the door to the processing lab. The sheer array of options available can be daunting and it is here that you first start to see the benefits of good technique when making the photograph.

Working in RAW

An image captured using the RAW file format cannot simply be opened and used. It must be saved in a different image format before use. It is during this saving process that all the information which describes the way an image will look (color space, color

temperature, brightness, contrast, exposure, sharpness, etc.) is assigned to that image. Until the point of saving, the RAW file format allows you to modify any or all of the parameters without diminishing image quality. This is achievable because the RAW data is all the data captured from the sensor so within the limits of the sensor's data capture, you can effectively pick and choose image data.

If we think of all the data captured by the sensor as choosing the ingredients that make up a meal then this is a little easier to visualize. When we take a photograph, as either a JPEG or a TIFF, the amount of each ingredient is selected by the chosen camera setting to make that meal. The camera's internal processing decides which color space, how much sharpening, etc. If we think of, say, contrast as the salt in the meal, the camera settings that you choose determine how much salt, or contrast, is added

A RAW file should be thought of as an unprocessed image. It's important to realize that, as with an unprocessed negative or transparency film, the best results will be achieved if the original image is captured with accurate exposure, focus and color balance. In processing the RAW file, some shooting errors can be corrected, without degrading the image, but it is not a cure all or substitute for poor camera skills.

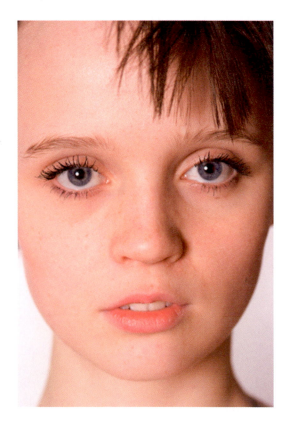

but once added it isn't easy to take out again. When using the RAW, the software will tell you how much salt, or contrast, the camera settings suggest you add, but give you the option to add more or less before it's too late.

This applies to a range of parameters which define an image and you can, for example, adjust exposure errors at this stage within a range of ± 2–3 stops, dependent on the sensor's capabilities. The down side of working with RAW is that it can be very time-consuming processing each image individually. For images shot under the same constant studio lighting conditions this is much more easily achievable; however, in natural light, especially when dealing with a batch of images shot in different or changing light, individual processing of each image is advisable.

The only image parameters that can't be altered when processing a RAW file are aperture, shutter speed and sensitivity (ISO), so post-processing doesn't allow you to alter these important compositional elements of an image. These are fixed at the point of capture. Thus, when you open a RAW image in your RAW processing software you will see a control panel with a plethora of image parameters which can be adjusted non-destructively before saving the image. These parameters describe everything about that image from the obvious ones like exposure and color values, through to less-intuitive ones such as 'recovery' and 'clarity'.

Again the key to processing a RAW image is not in understanding the subtleties of every option available, but more in understanding the ones that will allow you to optimize an image which has been well captured with accurate focus, exposure and color balance. It's unwise to view RAW processing as an opportunity to rectify all the anomalies introduced by poor technique when shooting an image in camera. Where you do need to make changes these should be done at the RAW processing stage, not once the image has been saved into a different file format.

When saving a RAW file the original is not lost either because you can only save in a different file format. You therefore have two copies of the image with the original image effectively acting as an original digital transparency, a 'digital master', which you can return to in the future if you decide you want to process an image differently. RAW processing simply overlays your selected changes but doesn't apply them permanently to the original RAW image file.

When opening a RAW file, it opens in RAW editing software. This then gives a range of options relating to the image properties — exposure, color etc. — which can be customized for that image.

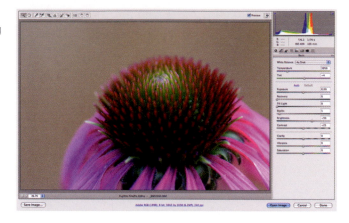

Post-Capture Exposure and Color Balance

The first stage of looking at exposure post-capture is to identify any areas of the image where the highlights or shadows have blocked-up; in other words, where brighter areas have gone to featureless white or darker areas gone to featureless black. It is quite possible that the sensor has captured image detail in these areas that, because of the default settings used, is not visible. So our first step is to see if there is information that we can extract in the processing of the RAW file.

Fine-Tuning Exposure

As with most digital manipulation there are several ways to do the same thing but most software has now adopted the convention of showing underexposed areas as blue and overexposed areas as red in the RAW processor, making these areas easier to identify. Coarse adjustments can be made using a simple linear slider. If the color curves are visible in the processing window you will see these shift to the left when you darken an image and to the right when you lighten it.

As you make these adjustments you'll see the blue highlighted, underexposed areas and red highlighted, overexposed areas change. Decreasing exposure, darkening the image, decreasing red and increasing blue. Increasing exposure produces the opposite effect. Once you have made these adjustments you can fine-tune them using the 'recovery' feature. Your objective

should be to change the exposure to match the effect which you want to achieve with each image. As part of the creative process this may even include deliberately under- or overexposing an image to achieve low-key or high-key effects.

Where you have both under- and overexposed areas in the same image, post-capture exposure adjustment is a balance but you can also adjust contrast to try to bring out image detail in both. Again, there is a linear slider to make this adjustment, but if you feel more confident with image manipulation then it's better to use the levels and curves features to make all these adjustments to exposure and contrast.

In most RAW processing software the visual representation of levels and curves superimposes one on the other to aid you when making adjustments. It is advisable to have the image preview

Exposure can be adjusted and fine tuned in the RAW editor software. The image (top) shows the RAW file open in the RAW editor. The image is slightly too dark and detail has been lost in the face. In the middle image, the shot has been lightened using the Exposure slider, over-exposing by +0.35 stop. This lightens the whole image which can now be fine tuned. Here that has been done using the Fill slider to lighten the darkest tones very slightly.

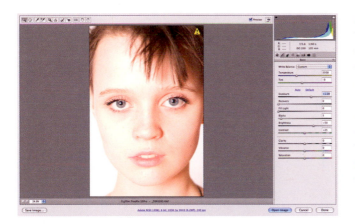

Using the exposure slider, the curve at the top right of the editing screen gives a guide as to where clipping occurs. Here it shows red, green and blue curves combined but each color curve can also be adjusted individually. The middle image shows the exposure recorded in camera. In the top image the RAW editor has been used to over-expose the image by one stop, giving a high key lighting effect. In the bottom image the exposure is adjusted to under-expose the image by one stop and, in this instance, gives a less flattering effect.

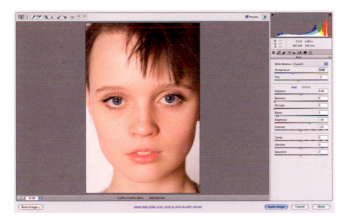

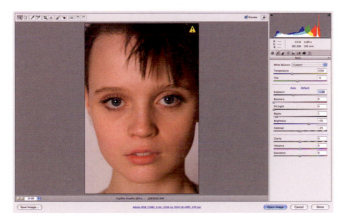

Color balance is customizable in a RAW editor, either using the preset menu options similar to the ones in your camera, or using the temperature slider to give precise adjustments in degrees Kelvin (K). In the first shot (top) the color temperature is set to 3200K, the color temperature of tungsten light, and the image looks blue. In the second shot (bottom) the color temperature is 4500K, nearer that of fluorescent light.

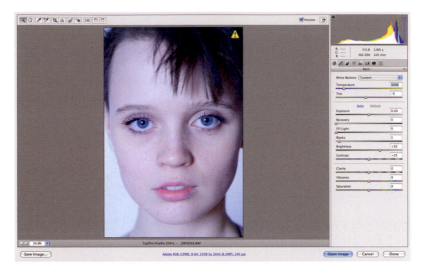

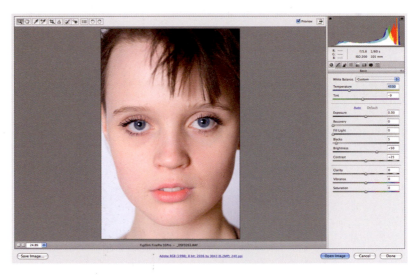

function switched on so that you can see all the adjustments as you make them, giving you greater control over processing your image.

Making Decisions on Color

Adjusting color in a RAW image is absolutely dependent on color calibrating your monitor first. If you don't do this you simply can't make accurate color decisions about your images.

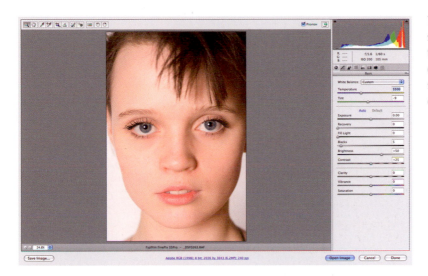

The top shot shows how the skin tones reproduce at 5500K, the color temperature of natural daylight, while the image below shows the effect of warming the color temperature to 6500K.

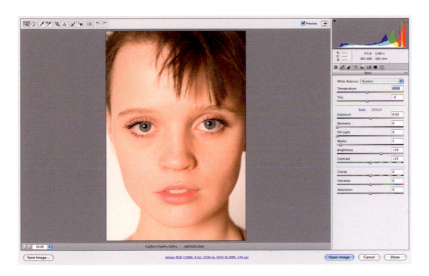

Whenever anyone mentions color in connection to digital images, the dreaded words 'color management' inevitably follow. Color management is surrounded in mystique and sometimes impenetrable terminology, but is not something to be feared and the process of calibrating your monitor is relatively easy.

To do this you need color management software which usually comes with a small device or colorimeter, that looks like a

computer mouse. The colorimeter is placed on the computer screen while the software runs a series of predetermined color displays. This generates a profile for that particular monitor that, when installed, adjusts the monitor to match the true colors in any image by removing any inherent color cast which the monitor produces. The effects can be either subtle or dramatic depending on the monitors; however, once done, you can be sure that what you see on the screen is the same as the color recorded by the sensor. Only then can you accurately adjust color in any image, but this process should be repeated every few weeks or months as monitor color casts can change with time and use.

The first thing to look at is color temperature. Typical daylight has a color temperature of around 5500–5600 K, except around sunrise and sunset. When shooting with the white balance, or color balance, set to auto, the camera assesses color temperature and makes adjustments. Remember though, that the camera doesn't have a brain so it is only making these changes according to a set of pre-programmed options. Using auto white balance, the camera makes this correction on an image-by-image basis so any two images may have slightly different color temperatures assigned, dependent on image content and direction and intensity of light, even when taken at the same place and time. This means that color temperature must be adjusted individually for each image.

This is further complicated because some camera manufacturers, most notably Nikon, carefully guard the way their cameras assess color temperature so, unless you are using their proprietary image manipulation software, color temperature is at best an approximation. This is another good reason why you must color calibrate your monitor before attempting to alter color in your images.

RAW image processing software gives you options to view an image's white balance as shot or in different lighting conditions such as sunlight, shade or under artificial lighting. Scrolling through the options clearly illustrates the marked differences in color temperature under different lighting conditions. Try this with one of your images. These differences are often not registered when viewing with the human eye because our brains make corrections to the colors to interpret colors as we expect

to see them. The only times we can see this clearly are when we suddenly go from dark to, say, bright tungsten lighting and an orangey color cast is visible for a few seconds. This is also evident when taking a photograph in indoor lighting without a flash and the particular lighting produces a color cast; orange for tungsten, green for fluorescent, etc.

Color balance can be set in camera but RAW gives you the option to adjust these settings. This is especially useful in mixed light when it is advisable to shoot an image balanced for the dominant light source, then make fine adjustments when processing. If you know the color temperature of the dominant light source then this can be set in camera, either using the appropriate symbol settings or by choosing the color temperature in Kelvin. Adjusting the color temperature control also moves the tint slider because the two are directly linked.

An alternative to using the color temperature slider is to use the white balance eye dropper tool. This allows you to select the part of an image which should be balanced as white and adjusts the color of the whole image relative to the selected part.

Using the HSL (hue, saturation, luminance) menu, individual color tints can also be added or removed. The vibrance control can be used to soften color saturation and this is often useful in portraiture.

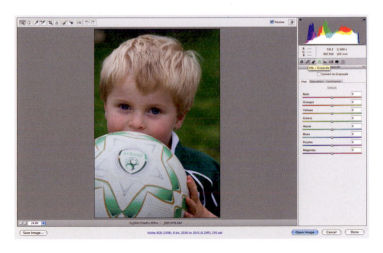

Amongst the array of processing options are adjustments like hue and saturation. These can be particularly useful on certain, but not all, images. Before you start processing any images in RAW it's worth taking time to familarize yourself with the options available and how they alter an image.

The possibilities to edit and transform an image in image editing software such as Photoshop are vast. Many of these take an image a long way away from the photographer's original vision. Exploring the options is worth doing but at some point this manipulation stops being photography.

Fixing Digital and Optical Aberrations

Optical aberration is cause by the optics of a camera lens. Cheap cameras tend to be fitted with cheaper, lower optical quality lenses so are more prone to introducing optical aberrations or artifacts into an image. These can take the form of distortions to the image, particularly around the edges of the frame, or chromatic aberration seen as color fringing. Lenses are weakest when working at their limits of aperture and range. Zoom lenses tend to be more prone to optical aberrations than prime, or fixed focal length, lenses simply because of the compromises which their construction requires to offer variable focal lengths. The simple solution is to buy the best lenses that you can afford.

There is some good software available to correct optical aberrations. One in particular, PT Lens (epaperpress.com), works either as a stand alone application or as a Photoshop plug-in. Corrections are available for a huge range of different makes and focal lengths of lenses.

Chromatic aberration can also be caused digitally, whereas moiré effects and digital noise are both digital artifacts. All

three can be minimized but not completely removed during RAW processing. The lens corrections menu allows correction of red/cyan fringed or blue/yellow fringed chromatic aberration using simple slider scales. It also allows lens vignetting to be applied. Moiré effects are visible as step-like edges rather than smooth, defined lines, and are most noticeable where contrast between a line and its background is highest. This is best removed by softening an image, either all over or selectively.

Digital cameras perform worst in very low light and with long exposures. This combination causes digital noise. This is most noticeable in the darker areas of an image and manifests itself as red, green and blue dots. Many cameras have inbuilt options for noise reduction but this is again best done at the RAW processing stage. The noise reduction tools can be found under the detail menu along with sharpening. Digital noise is reduced using a combination of adjustments to luminance and color.

Camera noise reduction settings offer an in-camera software method of reducing the digital noise produced with long exposures.

Fine-Tuning a Digital Image

All the elements that make up basic retouching can be applied while processing a RAW image. Basic retouching includes cropping and straightening, removal of dust spots and blemishes, removal of unsightly elements of an image, adjustment of levels and curves/brightness and contrast, color balance, and hue and saturation. Of these elements, only the last three are covered elsewhere in this chapter.

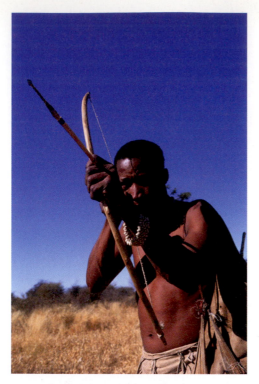

Sometimes we make mistakes when shooting an image and some of these can be rectified or reduced using digital imaging software. In this shot the light on the San Bushman's face is harsh, giving dense shadows around his eyes, and a distant tree is just visible over his shoulder.

Increasing the image size on the screen so that individual pixels can be seen will allow more accurate image editing.

By making a selection then inverting it, the Bushman's body can be masked off and the clone/stamp tool and healing brush can be used to edit out the tree.

The bright highlight on the Bushman's forehead can be darkened using the burn tool.

The healing brush can also be used to remove the shadow of the bowstring on the Bushman's forehead.

The shadow around the Bushman's eyes can be reduced using the dodge tool. Care should be taken not to over-lighten this area as this will look unnatural.

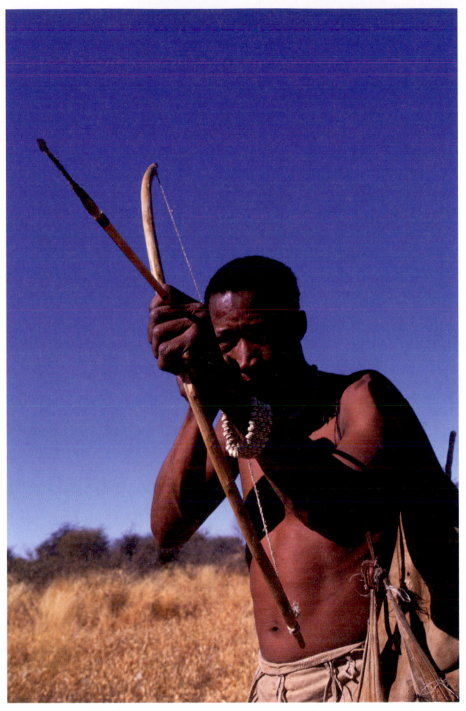

Comparing the edited version with the original it looks much cleaner and has more impact.

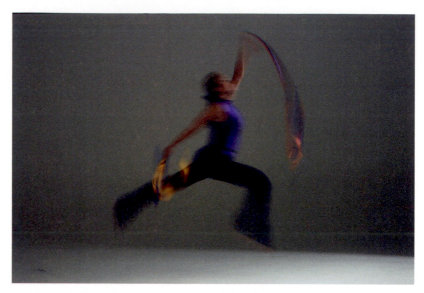

This image was deliberately shot using a shutter speed which allowed some motion blur. When you shoot an image, and before exploring the many ways in which that image can be manipulated, it's important to have a clear vision of what you want the final image to look like.

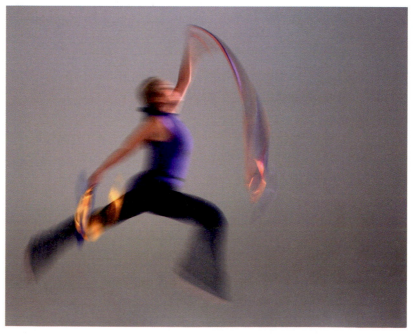

The first stage of manipulation is to tidy up the image. Here the image has been cropped and the tonal line between the floor and wall behind has been removed giving on image which works in its own right.

Photoshop has an impressive array of preset manipulations, which can then also be customized, and these can be found under the Filters menu. These are mainly art based rather than photographic but it can be fun to play around with them. Here the glowing edge tool has been used to create a colored line drawing.

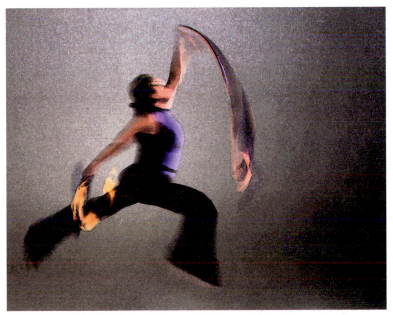

The Watercolor filter creates a stylized artists impression of the original image. Such filters should be used with care and here you can see banding in the background which is not visible on the original photographic image.

The cropping and straightening tools are both simple to use and self-explanatory. To crop an image select the tool, place it on the image then drag it across the image to form a box delineating the areas to be cropped. This cropping box can be resized afterwards so don't worry if you aren't completely accurate first time. If you make an error and want to start again simply press the escape key. Pressing the return key accepts the crop. The straightening tool actually crops and straightens at the same time. With this you select the tool then place it on the image along or adjacent to a line which should be either vertical or horizontal, a horizon for example. Drag the tool along all or part of this line to straighten. When you press the return key, the image is straightened and cropped to the maximum usable area.

RAW processing software offers two options for retouching dust and marks on an image, or editing and removing elements of the composition – heal and clone. However, using software such as Photoshop gives you more refined options for fine-tuning any retouching done first in RAW.

Selecting the retouch tool gives both options. The cloning tool simply selects an area of the image and copies it to the area to be retouched. You can set the size of the copied area by highlighting and dragging the tool or using the radius control, then choose where to paste it. The healing tool uses blending to merge the colors and textures of the selected area into the area being retouched. To retouch well you will most likely need to use a combination of both.

The big advantage of retouching in RAW using these tools comes when you have dust or marks on the sensors. These are invariably in the same place on all your images taken on the same shoot. RAW processing creates a retouching layer which overlays an image so you can retouch sensor dust and marks on one image and apply this to the whole batch.

Once the image has been processed in RAW and opened, delicate retouching can be done in digital imaging software that comes with a more refined selection of retouching tools to allow greater control of brush size, softness and blending modes.

Selective Exposure and Color Control

For selective adjustments to either exposure or color it's best to use layers in image manipulation software such as Photoshop. Here you can create non-destructive, reversible adjustment layers to mask selected areas of an image.

Choose the 'New Adjustment Layer' option from the layers menu and create an adjustment layer. If you have the layers tool palette open on your desktop then you will see and be able to select this new layer. Apply a black fill to the new layer then select the white brush and create the mask over the area which you wish to adjust by painting through the fill layer to expose areas of the

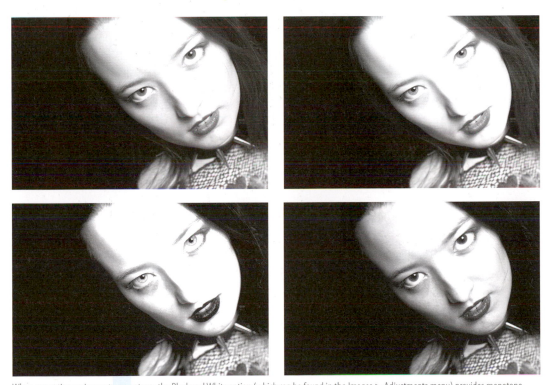

When converting an image to monotone, the Black and White option (which can be found in the Images > Adjustments menu) provides monotone conversion with a variety of B&W filtration options. You can experiment with these but it's important to understand how different colors and tones reproduce in B&W. Here the options show how different an image can look dependant on which filter you select. Unfiltered B&W conversion (top left), conversion for maximum blacks (top right), conversion using green filter (bottom left) and conversion to infrared (bottom right).

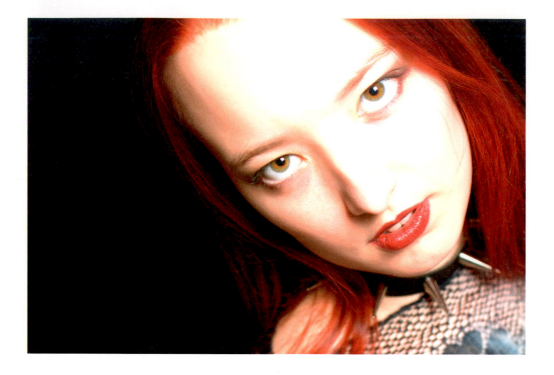

image. If you use a white fill and black brush you can mask-off areas of the image.

Using this technique you can create adjustment layers for a whole range of adjustments, from levels and curves through to selective exposure and color adjustments.

Creating a Monotone Image

There are a multitude of ways to produce a black and white image with a DSLR, although most result in rather weak images compared with the strong tonal range afforded by black and white film, so this is one area where following best practice is not only advisable but essential.

Black and white images can be produced by either setting your DSLR up to shoot in monochrome or by desaturating images shot in color. It's preferable to shoot your images in color then to use all the color information to obtain a grayscale and

create a black and white image in your image manipulation software.

From Photoshop CS3 onwards, there is a competent black and white conversion tool, found in the image adjustments menu, which allows you to control and adjust all of the color channels individually. Alternatively, you can apply various predefined options from a drop-down menu that simulates different color contrast options that would typically be produced by filtration, or in the case of infrared, special film.

The alternative to this approach is to convert the image using Lab color. From the image mode menu convert the image to Lab color then select the lightness channel and discard the other channels. Now convert the lightness channel back to RGB.

The approach you take also depends on how you are going to use or output an image. If, for example, you only have a cheap printer then a simple grayscale conversion of an image is likely to yield as good a print as the printer is capable of rendering. If, however, you're using the latest top of the range inkjet printer then it's worth spending time to create the best monochrome possible and letting the printer reproduce it in all its glory.

Sharpening

Many photographers don't realize the effects that sharpening, and when you sharpen, can have on an image. All digitally shot images require a degree of sharpening as an artifact of the way the image is captured, so digital cameras often apply this internally. Some cameras allow you to apply varying degrees of sharpening at this stage but this is not advisable as sharpening should be applied only once, customized to the output device, and should be the last stage of manipulation before outputting an image.

Often books and courses on digital image manipulation try to quantify the amount of sharpening which should be applied to images but this is unrealistic and inadvisable. Sharpening is image-specific and so should be individualized to each particular

When converting an image to black and white, select the Black & White tab in the Image > Adjustments menu. A new drop down menu then appears which allows you to select different filtration options from a preset selection or to custom filtration as you wish.

Note how the different color filters alter the way in which different colors reproduce. Here a blue, green and red filter have been applied respectively. With the blue filter (top), any element with blue tones has been lightened (e.g. the jug) while the other tones have darkened. Similarly with green (middle) and red (bottom) filters anything the same color as the filter is lightened. Green and red have a similar tonal value in a B&W image but using filtration it's possible to change the tone of one making it possible to tell the difference. Here the red and green fruit are most distinct when the red filter is applied.

These software filter settings are only an approximation of the effects which would be achieved by filtering the light entering the camera. However they do provide a simple and flexible way of creating B&W images. Here a color portrait with muted tones (top left) has been converted to B&W using the Photoshop Black and White tool (top right) but the addition of a red filter (bottom left) works particularly well for this image.

In any image, and particularly in portraits, a good balance of tones and tonal range gives the most pleasing results.

image. Far more important is to have an understanding of how best to apply sharpening, when to apply it and when not to apply it.

Most image manipulation software gives you several different ways to sharpen an image and these are usually found in the filters menu. In Photoshop, the most useful of these, rather counter-intuitively, is a tool called 'Unsharp Mask'. When selecting this option a dialogue box opens with three different parameters: Amount, Radius and Tolerance.

The first of these, Amount, is expressed as a percentage and is dependent on image resolution. Thus, a low-resolution image at 72 dpi requires less sharpening than a higher resolution image at

The last stage of manipulation before outputing an image to print should always be sharpening. This should be customized to suit the reproduction, and this process should only ever be performed once on an image – never re-sharpen a sharpened image. Sharpening increases edge contrast and here the effects can be seen by comparing the unsharpered image (top left), the sharpened image (top right) and the over-sharpened image (bottom).

300 dpi. This image-dependent variability is a key factor in why it is not possible to give hard and fast guidance on the amount of sharpening to universally apply to your images.

Radius is a measure of the number of surrounding pixels which are affected by applying sharpening. This can be set to a very low level to achieve a subtle effect or higher to include a number of surrounding pixels, producing a cruder or harsher end result. The third parameter, Tolerance, is a measure of the threshold at which you want the sharpening to take effect. Again, no hard and fast guidelines on the exact measure can be given, and this is best applied by visual interpretation.

Sharpening should be applied to images before output to print or for publication but the degree of sharpening is dependent on how an image is to be reproduced. If you output your images to your own printer you can experiment to determine the best setting for your particular images and set-up. If you are sending images to an external printer it is best either to advise them that your images haven't been sharpened, allowing them to apply sharpening as required, or to ask their advice on the degree of sharpening to be applied.

If you are intending to use your images on the web then you should not apply any sharpening. This is because sharpening introduces edge contrast, increasing the file size when the 'Save for Web' function is used.

The Digital Print

The ability to be able to produce your own high-quality print of one of your images from an affordable desktop printer is perhaps as much of a revolution as the advances in DSLRs themselves. It is easy to forget that these advances in printing are equally dramatic, making printing so much more accessible and cost-effective.

Much of the preparation for print again involves good technique when making the image in camera, combined with the right choices when processing the image in computer. To accurately and cost-effectively produce prints it is important to ensure that each stage of the process relates to the next one.

Every part of the photographic process is important, from visualization through to final output.

The first step in this process is to make sure that what you see is what you get. This takes the photographer further into the realms of color management. This domain is shrouded in mystery but it is far less complex than you might imagine. Quite simply in order to be able to make informed choices about processing an image and how it will look as a print then you need to calibrate what you see on your computer screen to match the print that your printer produces. The variables in this process are the monitor, the paper you print on, the inks in your printer and the printer itself.

It is a good idea to standardize the printing paper and ink that you use. First test some different printing papers and choose two

To produce consistently good photographs you must learn to see how the camera sees and use the tools at your disposal to capture the images you first percieve in your mind.

or three that you like. An example of this would be a gloss, a satin (or semi-matt) and a matt finish. Alternatively you could select one for color and one for black and white images. The papers don't have to be the same brand but sometimes this can simplify matters a little. Similarly, find a brand of inks you like and stick with these. Your choice doesn't have to be the proprietary brand of your printer but you may invalidate any warranties if you use generic brands. Also, if you're using the same manufacturers paper then both printer and paper have been designed with that brand of ink in mind. As with DSLR cameras themselves, the better quality printer, paper and inks you use, then the better the end result. With digital photography, as a rule, the more you

spend, the better the quality – and this holds true for everything from sensors to lenses.

The Way to Better Digital Photography

The mantra 'shoot to the max' should apply to everything you do with your DSLR. Every part of the photographic process is important, from seeing and composing an image through to output of the image to print or on the web. The end result starts with the choices that you make when shooting an image. If you want to be a good photographer you must learn to see and compose images in your head. You can then choose the camera and lens to capture that image. Set your camera up to capture maximum quality as a RAW file (with JPEG preview image) in the largest color space achievable. When you make a photograph, do it with good camera technique and accurate exposure. Don't take the approach that you can fix the image later in your computer – you can't! If you don't get it right in camera everything else is a compromise.

Remember the adage 'a chain is as strong as its weakest link'. Every step of the process, from capturing an image through to its final use, is as important as the next and should be done to the highest achievable level. If you take this approach your photography will blossom and you'll make beautiful images that you can be proud of. Finally, your photography is your own personal view of your world. It should be limited only by your own imagination, so be creative!

Index